Gardens in Pastel

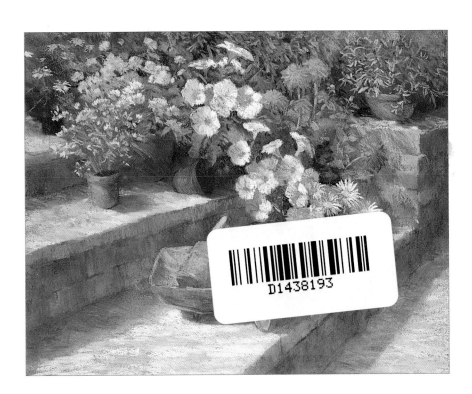

JACKIE SIMMONDS

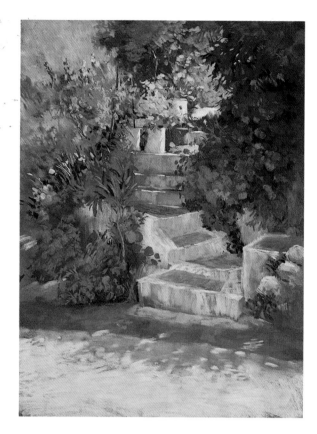

Dedicated to my much-missed mother,
who would have adored this book.

First published in 1997 by
HarperCollins*Publishers*
77-85 Fulham Palace Road
Hammersmith
London W6 8JB

The HarperCollins website address is:
www.**fire**and**water**.com

Collins is a registered trademark of
HarperCollins Publishers Limited.

01 03 05 06 04 02
3 5 7 9 8 6 4

**A catalogue record for this book is available
from the British Library**

Editor: Tess Szymanis
Photography by Jon Bouchier and Ken Grundy

ISBN 0 00 413340 4

Colour reproduction by Colourscan, Singapore
Printed and bound by Printing Express Ltd, Hong Kong.

A companion video, also entitled *Learn to Paint Gardens in Pastel*,
is available from Teaching Art Ltd, PO Box 50, Newark,
Nottingham NG23 5GY; telephone 01949 844050.

PREVIOUS PAGE: Trug, Pots and Flowers
38 × 51 cm (15 × 20 in)

THIS PAGE: Garden Steps, Greece
66 × 48 cm (26 × 19 in)

OPPOSITE: Majorcan Patio Pot
20 × 29 cm (8 × 11½ in)

CONTENTS

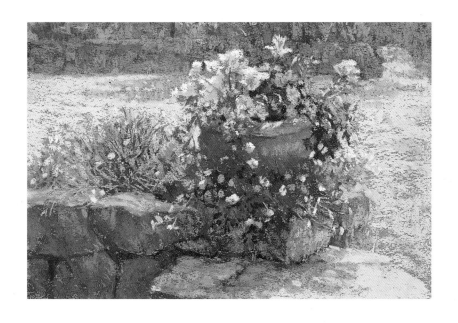

PORTRAIT OF AN ARTIST
JACKIE SIMMONDS

Jackie Simmonds was born in Oxford, and now lives and works in Northwood, Middlesex. Originally trained as a secretary, she had a business career for ten years running a successful London-based employment agency. However, she nursed a burning, secret ambition to be a painter and, eventually, as a mature student, she took up a four-year, full-time course at Harrow School of Art.

After graduating she started to work from home, producing paintings for exhibitions and teaching as an Adult Education painting tutor for the Harrow Arts Centre. Encouraged by becoming an award-winner at

▲ *Jackie Simmonds painting in her garden.*

the 1985 Pastel Society exhibition in London, pastels soon became her favourite medium.

She exhibits her work regularly in galleries in England and the United States, and she has had work shown by The Royal Institute of Painters in Watercolour, The Royal West of England Academy and The Royal Society of British Artists.

In 1987, Jackie was asked to do a series of paintings for reproduction as fine art prints; many of her pastel paintings have since been reproduced and sold throughout the world. In l992, one of her pastel paintings took first prize at the Chevron-sponsored, national Art in Nature exhibition. Soon afterwards she was commissioned to write her first book, *Pastels Workshop*.

When she is not painting, Jackie writes articles regularly for *The Artist* magazine, and organizes teaching courses and workshops for them in England and abroad. She also runs popular one-day workshops in her studio and garden at home each year, and often visits art clubs to provide demonstrations, workshops and critique sessions.

She maintains that her paintings are a direct response to the pleasure she feels and the beauty she sees in the world around her. She will tackle anything from market scenes and wild flower fields to figures and intimate still-life subjects. Her subjects are diverse but she confesses to a preference for aspects of nature, hoping to capture and share with her viewer the quality of light, the mysterious shadows and the lovely shapes that excite her interest.

▼ The White Chair
30 × 38 cm (12 × 15 in)

PAINTING GARDENS IN PASTEL

Pastels are a superb medium for painting gardens and flowers, since the colours are rich and vibrant and the textured surface of your paper, when covered with pastel particles, will reflect light to give added depth and sparkle.

Because pastels are opaque, it is possible to paint light colours over dark ones and, likewise, dark colours over light – this is a particularly useful quality when trying to capture the complexity of a mass of foliage and for painting the palest of petals.

You will find that the approach I take is not that of the botanical painter. I could not even begin to tackle a garden scene if I had to paint every leaf and flower. Instead, I try to capture the essentials of the subject – life and movement, glorious colours, the flickering light, the appeal and magic of an intimate, sunlit corner. If you are a beginner, remember that it is possible to start in a modest way – success with a terracotta pot filled with daisies will give you confidence to tackle a more ambitious scene.

In common with many amateur painters, my original choice of medium was watercolour. I struggled with it, producing many more disasters than successes, vainly hoping that one

▼ Garden Path, Chenies Manor
30 × 48 cm (12 × 19 in)

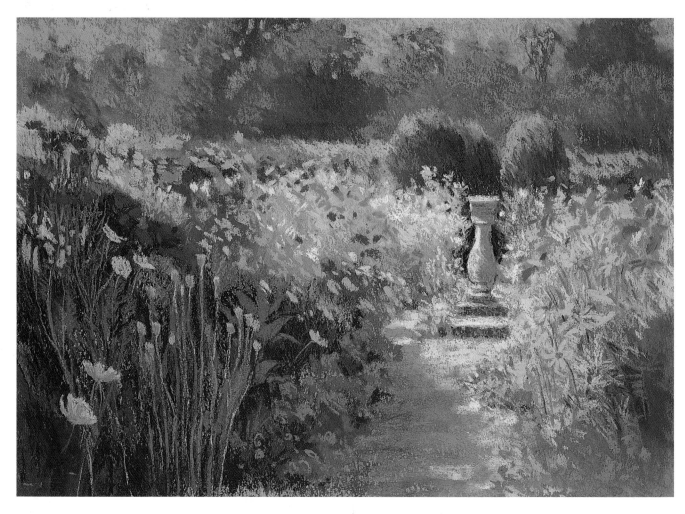

6

day I would find effortless masterpieces at my fingertips! Alas, this glorious day is still to come; it may never do so, because I have lost my heart to pastels.

WHY USE PASTELS?

After using watercolour, the immediacy of pastels astonished and delighted me – it still does. It is a dry medium and it is possible to work in an uninterrupted way from start to finish – no waiting for paper or paint to dry! This will work to your advantage when painting flowers and gardens, since a flower's life is fairly short, and capturing the light in a garden scene is best done with some sense of urgency!

Pastels are extraordinarily versatile – a light, careful touch will produce a subtle, sensitive mark, while bolder handling will produce vibrant, dynamic results. Moreover, as you work, it is a great comfort to know that mistakes can be rectified easily by simply brushing off the pastel, or by working over the top. This encourages spontaneity and experimentation. It's easy, and fun, to develop your own personal 'handwriting' of marks and strokes. If you are new to pastels, you will be amazed how quickly this will happen.

Throughout this book, I will offer you many tips and ideas on how to help you use your pastels to create lovely flower and garden images. However, it is important to realize that, even if you try to paint exactly as I do, your images are unlikely to look exactly the same as mine. This is because you and I are two different people and our work will reflect that fact. The step-by-step

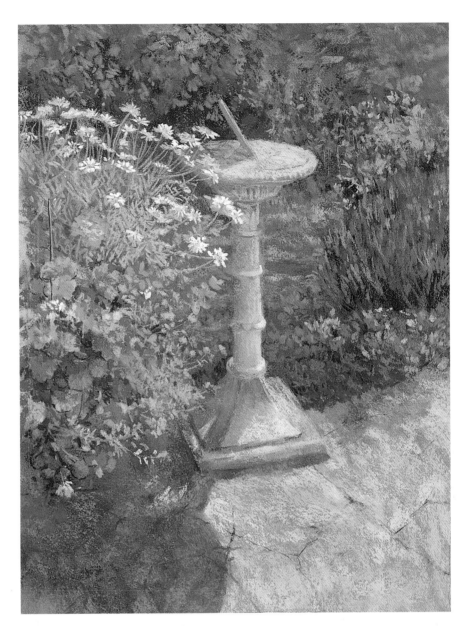

demonstrations will show you how I develop my paintings and are there to give you ideas about painting garden scenes, to answer questions which may come to mind when you attempt your own flower-filled images and to encourage you to approach your subjects with greater confidence.

Hopefully, I will have stimulated your enthusiasm, since there can be few greater pleasures in life for artists than the satisfaction of managing to capture for ever a little of the beauty we see before us.

▲ The Sundial
51 × 38 cm (20 × 15 in)

MATERIALS AND EQUIPMENT

A visit to an art shop to buy materials is always fun. Choosing pastels and pastel papers is particularly enjoyable, because they are both available in a wide variety of mouthwatering colours and tones.

Pastels are sold loose or in boxed sets. If you find it too difficult to choose loose sticks from the rainbow assortments in the art shops, then begin with one or two boxed sets – a landscape plus a portrait set or one of the more general ones. This will give you an excellent starting point. You can then add loose sticks from time to time. Otherwise, if you want to choose your own colours, a sensible rule of thumb is to make sure that you select light, medium and dark tones of the colours you like, ensuring that as well as bright colours, you have a good range of subtle greys and more neutral colours.

TYPES OF PASTELS

Pastels can be bought in various forms, the most common being soft, oil and hard types. I have used these throughout this book, but if you wish to experiment further, you can try wax pastels as they are also water soluble.

▼ *A selection of soft, hard, oil and wax pastels.*

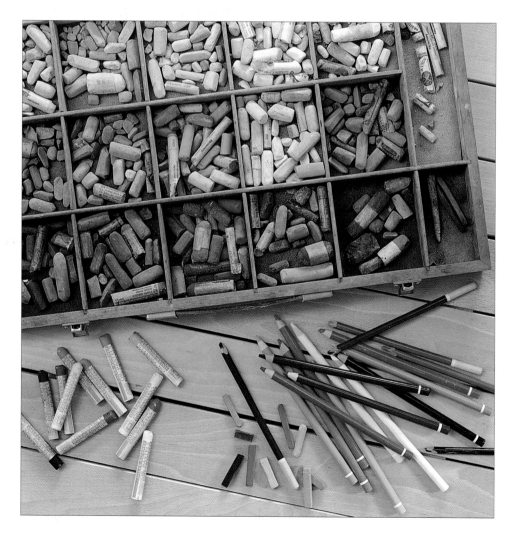

SOFT PASTELS

Soft pastels contain chalk pigment mixed with a small amount of binding agent, so that their texture is velvety and smooth. The sticks are usually cylindrical in shape, and they are often individually wrapped for protection and identification. They have excellent covering power and are ideal for large areas, but small pieces can be useful for fine detail.

HARD PASTELS

Hard pastels are made with more binding agent than soft pastels and can be bought as square sticks or pencils. The value of a square sharp edge, or a pencil point, is that it can be used for sketching and details. Hard pastels mix well with soft ones, particularly when used in the early stages of a pastel painting.

OIL PASTELS

Because the chalk pigment is mixed with an oil binder, these pastels have a dense, moist texture. You can also blend and mix them with turpentine or white spirit. The colours tend to be bright and strong, but as there is only a limited range of colours on the market, colour mixing and blending on the surface of the paper is needed to extend their versatility.

▶ *These three examples show subtle differences in the effects achievable with different types of pastel. The materials not only feel very different to use, but if each was used exclusively for a painting, the finished images would also look very different.*

◀ *Soft pastels*

◀ *Hard pastels*

◀ *Oil pastels*

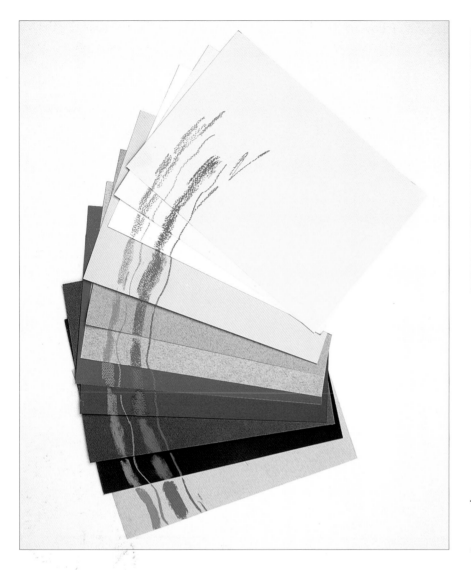

Tip

● It is important to realize that moistening any piece of paper under 640 gsm (300 lb) will cause it to buckle, so it is best to stretch your paper before you apply any paint. Simply soak your sheet of paper in water for a few minutes and then attach it to a wooden board using gummed tape – the kind you have to moisten yourself. Leave it to dry naturally; trying to dry the paper with artificial heat may cause it to shrink too quickly and to pull away from under the sticky tape.

◀ *A variety of surfaces are suitable for pastel work. From the top: three watercolour papers, five pastel papers, a pastel board and two examples of sanded pastel paper.*

SURFACES

Pastels are applied directly to a surface and this needs to be textured to hold the pastel particles – this is called the 'tooth' of the paper. Pastel paper has an excellent 'tooth' and it can be purchased in a wide variety of colours and tones. Most beginners buy the palest shades but, in fact, the easiest to use are the neutral, medium tints.

It is also possible to work on pastel board, which has a velour-like surface and requires no fixative. Sanded pastel paper, which is actually fine sandpaper, offers a gritty surface that allows a rich build-up of colour. The finished effect on both of these surfaces often looks as dense and luscious as an oil painting. Watercolour paper can be an exciting alternative, particularly if you like the idea of beginning with an underpainting in watercolour or gouache.

You could try creating your own textured surface by using Daler-Rowney Texture Paste. I have discovered that this fine paste, which can be diluted with water and painted onto board or paper, will provide an interesting, varied surface which grips pastel very well indeed. You can even add colour to the mixture, using acrylics or watercolours, to create your own varicoloured support.

FIXATIVE

Fixative can be purchased in aerosol-spray form or in a bottle with a mouth-type diffuser. If you prefer aerosols, do look out for ozone-friendly, low odour types. Although fixative is said to protect the surface of your work, this is a little misleading. It is definitely not to be used as a varnish, since heavy bursts of fixative will drench your work and darken the colours. A light burst of fixative while a painting is in progress will restore the 'tooth' and usefully allow overpainting. When you complete the picture, simply store it flat in a folder until you are ready to frame it.

OTHER USEFUL ITEMS

Pastels combine extremely well with charcoal, and a preliminary charcoal drawing is easy to correct because lines will dust off with tissues, leaving a faint suggestion of a drawing. Carbon and conté pencils are not as easy to remove, but can be useful if you wish to retain your drawing for some time; they can also be used for fine details in a painting.

If you wish to correct your work, a one-sided safety razor-blade, scraped gently downwards, will remove heavy layers of pastel, as will a stiff hog-hair paint brush.

Other useful items include: tissues for gentle blending; a hand-held mirror to look at your work in reverse, which helps you to see your picture anew and perhaps discover areas in need of adjustment; a small plastic 'veggies' tray from a supermarket to hold loose pastels while you work; a lightweight drawing board with bulldog clips to secure your paper; a sketching easel and sketching stool; and moist tissues for hand-cleaning at the end of the day!

If you are working away from home, make sure you either turn your picture to face your board when you have finished, or put both items into a large plastic bag. Either method will prevent a smudged picture!

At some stage you will need to clean your pastels. The simplest way is to drop dirty pastels into a tray, or bag, of ground rice or semolina. Give them a good shake and then drop everything into a sieve. Throw away the dirty ground rice, and store your nice clean pastels!

OUTDOOR EQUIPMENT

Working out-of-doors is usually exhilarating but it can be frustrating, particularly if your equipment is heavy and cumbersome to carry around.

If you like to work at an easel, look out for the ultra-lightweight, aluminium tripod types. These have collapsible legs that make them small enough to be packed into a backpack. For extra rigidity on slightly windier days, there is a useful hook at the bottom of the central support from which you can suspend something heavy.

▶ *Here is my Outdoor Set – everything fits nicely into my backpack, except for my drawing board, which I carry separately.*

Tip

● Many art shops now stock Fome Core – a shiny, white, virtually weightless board filled with polystyrene. I use it as a drawing board, particularly when I am out and about, since wooden boards can be rather heavy to carry.

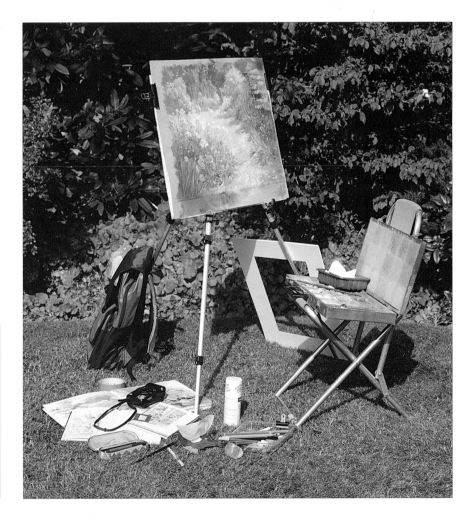

PASTEL TECHNIQUES

Many different types of mark can be produced with a pastel, and it is certainly time well spent if you practice. The experience you gain will be well worth the effort – although 'effort' is not really an appropriate word, since I have no doubt that you will thoroughly enjoy yourself! In no time at all, you will have a marvellous 'vocabulary' of techniques, quite literally, at your fingertips.

APPLYING PASTEL

The kind of mark you make will depend on how much of the pastel is in contact with the paper and how much pressure you apply. If you press hard for firmer strokes, the pastel may break – don't worry about this because small pieces are always useful, particularly for side strokes. In fact, it may even be a good idea to break new pastels in half before you use them – this will stop you from feeling intimidated by a long, fresh stick!

LINEAR STROKES

When the 'chisel edge' of your pastel is in contact with the paper you can create linear strokes, which will vary in thickness according to the pressure you apply. With use, a sharp edge will gradually become blunt, and the 'chisel' will become wider and produce thicker lines. If you want to make thinner lines again, simply twist the pastel around between your thumb and forefinger to find a sharp edge or corner again.

CROSSHATCHING
Pastel lines can evolve into crosshatching. This is a very useful colour-building technique, particularly when you use more than one colour to create unusual visual effects.

STABBING MARKS
The edge of the pastel can also produce a wide variety of dots, dashes, stipples, short strokes and scribbles – you are limited only by your imagination!

▲ *Practice makes perfect. I suggest you see how many types of mark you can make with the point of your pastel, as I have done here. Using the pastel for linear marks is great fun – it's drawing with colour! In a painting, linear strokes and marks add vitality and excitement.*

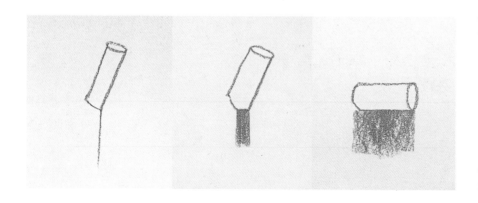

◀ *The different types of mark created depend on which part of the pastel is in contact with the paper.*

Different types of mark will create different kinds of textural effects. The density of the marks will also play a part – the fewer and wider apart the marks, the more the colour of the paper will show through.

SIDE STROKES

When you use the side of a pastel, you can cover large areas of paper very quickly. Applying a small amount of pressure to the pastel will allow the paper colour to show through, while heavy pressure will fill more of the tooth. The more textured the surface of the paper, the harder you will need to press to fill the tooth.

▲ *Here I have applied side strokes directly to the paper. In this instance, because the pressure applied was fairly light, the texture of the paper shows through the strokes.*

Tip

● The majority of beginners make the mistake of pressing too hard on their pastel, loading the paper with chalky pigment. Practice keeping the pressure light to begin with, building up your colour gradually.

LAYERING

Drifting one colour gently over another using the side of the pastel is called layering. This creates a lovely effect because hints of the under-colour show through, modifying the top colour. Layering works well over areas of flat colour that have been sprayed with fixative.

▲ *The darkest green was applied first and then the lighter greens were stroked lightly over the top. The dark green can be seen through the subsequent layers. This effect can be intensified, and new colours created, by using contrasting colours, such as blue and yellow.*

BROKEN COLOUR

Small pieces of pastel, used on their sides in short downward strokes, can be used to create areas of broken colour. By building up these strokes in a variety of tones and colours – a mixture of different greens, for example – the result will be far more exciting and effective than that of a single flat area of one tone and colour.

▲ *Here I used short strokes of broken colour to create a lively area of green. Because there are no lines to attract attention, the colours will blend together visually when used as an area of colour in a painting.*

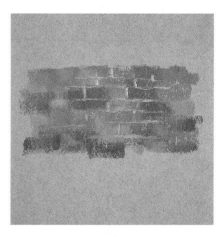

▲ *This garden wall was begun with side strokes of broken colour. Mortar lines were then added to suggest the brickwork.*

BLENDING

Having applied pastel to paper, it is possible to soften and blend colours together to create a smooth, velvety effect. Tissue blending removes pastel particles from the surface as you work, while blending with your fingers will press the pastel into the paper, resulting in a completely different, more dense effect. A torchon – a firmly-rolled tube of paper with pointed ends – will blend tiny areas effectively.

Blending too much of your image can result in a rather flat and monotonous surface. I recommend that you use blending selectively, perhaps in the early stages of your picture, so that you can draw linear strokes – stabbing marks, for example – over blended areas to make them more lively and interesting.

A little judicious blending with a finger or torchon to merge one colour into another – on a leaf, a petal or to soften a hard edge – is fine. Softened, blended edges in a painting will help to knit shapes together visually.

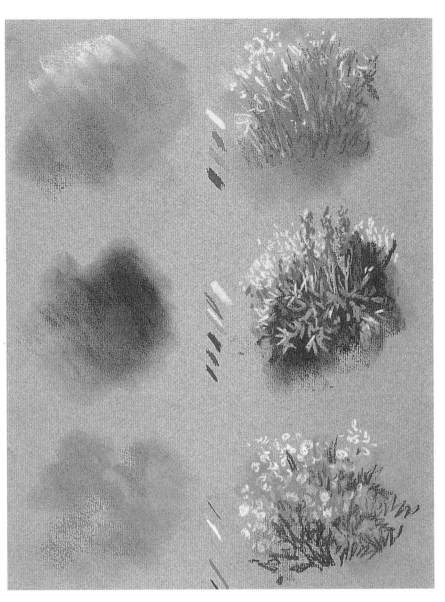

▲ These three colours were blended together using a finger. The result is a smooth, opaque finish, filling the tooth of the paper so that there is no obvious texture.

COMBINING TECHNIQUES

I believe that pastel paintings of garden scenes look their best when different techniques are combined to produce a lively, active surface, rather than a flat and monotonous one. After all, gardens are full of different textures, life and movement, and if you blend all your marks to create a smooth surface, you are unlikely to capture those particular qualities. Also, combining techniques allows you to exploit pastel's unique quality – you can draw and paint with it simultaneously!

▲ Side strokes of colour were applied to the paper and then finger-blended. Finally, linear strokes – dots, dashes and scribbles – were drawn over the top of the blended colours. The central illustration shows how a dark background can give an impression of depth under the lighter marks, whereas the bottom illustration, which was worked dark over light, creates a very different effect.

PASTEL WITH OTHER MEDIA

Pastels can be used with a variety of different media. Some artists use pastel over ink drawings, others over acrylic washes; I have even seen pastel used over an oil painting!

Perhaps the easiest and most fun combinations to try are pastel with watercolour or gouache. Both of these water-based media will provide you with an interesting, varicoloured surface on which to work, bringing a welcome change from the single tone and colour exercises worked on so far. Your underpainting could be quite abstract, or it could contain a suggestion of your subject.

The difference between the two media is that watercolour will provide a film of transparent colour, while gouache is more opaque and can provide areas of flat, solid colour on which to work. If, for instance, you wanted to tackle a picture which had dense, dark foliage areas in the background, initial varicoloured dark areas of paint could prove very useful because you could then use fewer dark pastels in the early stages.

▲ *Pink, blue and yellow watercolour washes were laid in a random fashion onto a piece of mount card, and then the leaves were drawn in pastel over the top. Yellow and pale blue-green pastels were side-stroked over the background, and the leaves to the left, to create a soft effect.*

▼ *On a piece of white watercolour paper, I floated blue and green watercolour and left the paint to dry before adding linear strokes of pastel. Notice how the pastel marks break up slightly because of the texture of the paper; you can see the colour of the watercolour through the pastel.*

▼ *Dark blue gouache, mixed with a little white for variety, was painted onto watercolour paper and left to dry. Stabbing marks of pastel were then worked over the top. The dark colour of the gouache provides a rich background for the pastel marks and, because it is opaque, it 'reads' as an additional colour. This could be exploited if, for instance, you wanted to extend your range of colours without buying more sticks of pastel!*

SKETCHING

Drawing is often neglected by would-be artists because they are so keen to produce a lovely colourful painting! However, glorious colour and clever techniques will not rescue a painting spoilt by poor drawing.

Drawing, or sketching, is the first step in learning to translate the three-dimensional world into a two-dimensional image on paper. Neglecting this first step will hinder your progress. Sketching practice will sharpen your powers of observation, and build up your confidence dramatically, as you gradually learn a 'language' which will help you to tell your story in the form of a first-class finished picture.

OBSERVATION DRAWING

Artists produce many different kinds of sketch, from rough notes to highly detailed studies of individual objects. When drawing flowers, it is useful to begin with fairly straightforward observation drawings. I suggest you begin with large, open flowers consisting of fairly simple shapes and large petals and then move on to the more complex flowers with masses of petals, such as carnations or roses, when you are more confident. Drawing like this in your sketchbook will familiarize you with your subject, so that when you come to paint you can approach it with much more confidence.

It is fun to try different drawing materials, too – pencil is usually the first choice, but do try working in charcoal, conté, or even ink. If you choose to use pencils, keep them well sharpened, particularly if you decide to use soft ones such as 2B or 3B. Try not to rely on an eraser too much, since this will blunt your determination to observe subjects carefully from the beginning.

LINE DRAWING

A drawing is usually a combination of line and tone (shading). However, it is possible to draw solely with line, using it to describe the outline of the object and its three-dimensional form. Ensure that your lines vary in weight by adjusting the pressure as you work – a monotonous line will produce a wooden, lifeless drawing. Look to see where light

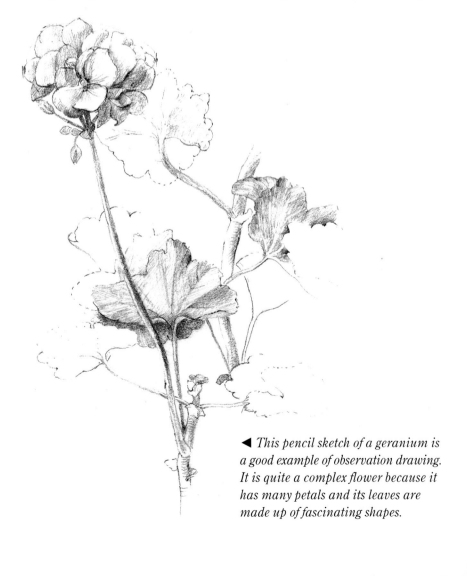

◄ *This pencil sketch of a geranium is a good example of observation drawing. It is quite a complex flower because it has many petals and its leaves are made up of fascinating shapes.*

strikes the plant, and where lines and edges merge and almost disappear. In these areas use your lightest touch and finest lines, perhaps even leaving a gap in places. Where there is strong contrast, and a shadow to throw an edge forward, you can use a heavier line. Heavy lines tend to attract attention and come forward visually, so leaves and petals which are less important, such as those at the 'back' of a flower, can be rendered lightly to help them to recede.

Your preconceived ideas about the shape of a familiar flower may have to be re-examined because what you actually draw will depend on the position of the flower. Is it posing beautifully for you, in a classic position? Is it looking directly at you, over its shoulder or down at the floor?

It is important to draw what you see, rather than what you think you see.

ADDING TONE

The three-dimensional nature of any object – its form – is only visible to us because of the way that light, hitting the object, creates shadows. If plants were all flat, like postcards, there would be no form to deal with in our drawings.

You can indicate the form by depicting light, medium and dark tones as accurately as possible. Tone can be rendered in many ways, and it is always good to practice. Look at the flower carefully and assess the relative lightness and darkness of each part by asking yourself questions as you work. Is this petal lighter, or darker, than its neighbour? How much lighter or darker? Build up your tones gradually.

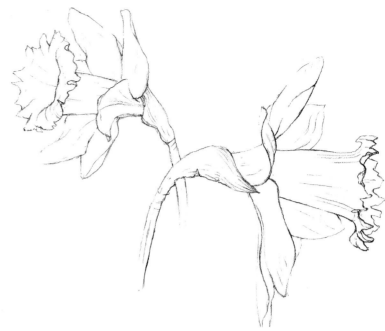

▲ *Line, without the addition of shading, can be used to describe an object's boundaries. Simple lines of equal weight can be descriptive and decorative, but lines which vary in weight are usually more expressive and help to convey a sense of form. In this drawing of daffodils, we understand how the petals curve because of the internal lines on their shapes, and we even have a sense of the light shining on the flowers where the line is less heavy or slightly broken. Dark, emphatic lines bring some parts forward; lighter lines push other areas into the background.*

▶ *These three little sketches show the development of a line and tone drawing. I began with the main shape of the flower, indicating its centre and stem. I then marked the outer edges of the petals and indicated the shapes of the leaves with a series of small dots. Finally, I was able to concentrate on developing the flower more fully. When working with line and tone, remember to be careful not to outline your plant with a strong hard line before you fill it in with tone. This can make a flower look like it has wire all around its edges!*

SKETCHING A SCENE

When you feel ready to venture out-of-doors, a very different situation will confront you. Drawing every leaf and flower would take months, wouldn't it! I suggest you now try a different kind of drawing altogether – the broad sketch, only indicating the general nature of the scene. You could start by selecting a corner of the garden, making a few lines here and there to indicate the main feature that attracted your attention.

Try one drawing working solely with line and then try doing another one using line and tone, indicating the main areas of light and dark at the beginning, half-closing your eyes to simplify the scene as you work. Giving yourself a time limit of 20-30 minutes for each sketch may help you to keep it simple!

Sketches of this kind are great fun to tackle. They can be kept purely for your own interest, or you can use them to form the basis of a subsequent painting.

◄ *Brown pastel pencil was used for this sketch of a flower border. I particularly liked the variety of shapes and sizes of flowers and the verticals of the bamboo stakes. The dark tones behind the flowers were built up by crosshatching.*

▶ *I sketched these floating water-lily pads from a high perspective using red and black conté pencils for the linear marks and the very dark tone of the flower bud. I used charcoal on its side for the water and some of the tones on the lily pads. Leaving the drawing unfinished at the edges gives a strong sense of the image being part of a much larger scene.*

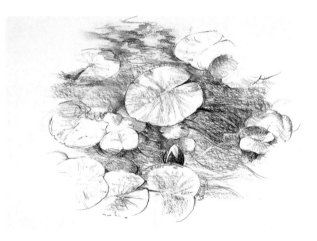

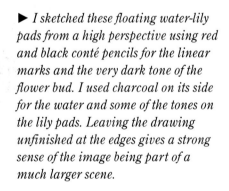

◄ *This sketch of a stone seat tucked away in a garden corner was done with a dark brown pastel pencil. Pastel pencils are excellent sketching tools because you can achieve dark areas of tone quickly and simply by scribbling with the side of the pencil point. You can sharpen the pencils to allow you to produce fine details, too.*

▼▶ These sketches were done using black conté pencil and charcoal, and I worked within a rectangle in order to assess which composition I would use later to do a full colour drawing. I began with line work, drawing the urn, stone seat, paving and some of the foliage. Then, working with the side of a charcoal stick, I was able to create soft shadows on the ground. Notice how the lines of the crazy paving show through the charcoal strokes.

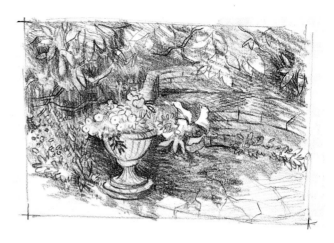

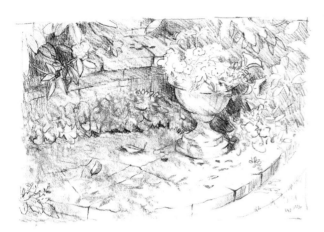

▼ Oil pastels were used for these lichen-covered stones and steps. I kept my sketch quite free and lively, using a variety of scribbles and dots to represent the foliage and lichen, overlaying colours loosely. I used a sketchbook specially made for use with oil pastels – between each sheet of primed paper is an interleaf sheet of greaseproof paper that protects your sketches.

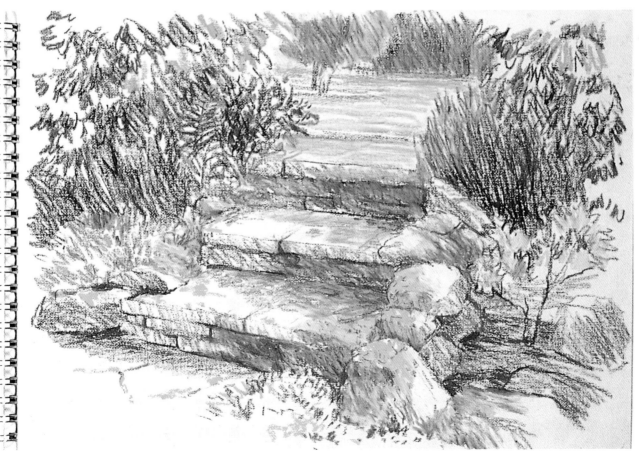

COMPOSITION

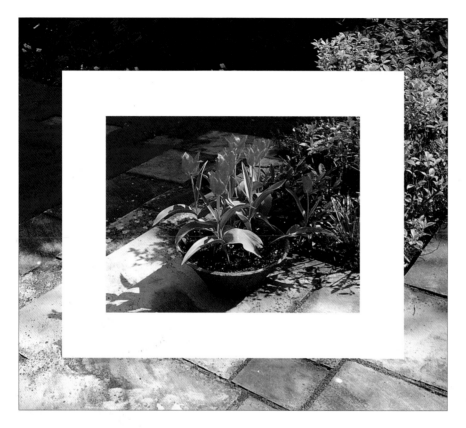

◄ *Cut a viewing 'window' from a rectangle of thin card. Moving this window either towards or away from you, as well as from side to side, will help you to find a scene which looks promising. It may also help to mark the edges of your rectangle, and similarly the edges of your paper, to give you reference points to work with.*

Composition means, simply, good design. It is my belief that the most successful and visually satisfying pictures are not necessarily those that are well-painted, but those that are well-designed. Does this surprise you? If it does, it may mean that you take composition for granted.

Many people assume that interesting subject matter will automatically provide a good composition, and sometimes, luckily, it does! However, relying on luck is rather haphazard, and I would like to offer you some suggestions to help you to create good designs in a more organized way. Time spent considering composition will, I promise you, pay great dividends.

SELECTING YOUR SUBJECT

The simplest way for you to select a subject from the vastness of nature is to use a viewfinder.

Having selected a suitable scene, I recommend that you then produce a little thumbnail sketch to see how the final image might look. If the first sketch doesn't 'feel right', try another from a slightly different viewpoint. These little sketches are really helpful – you can sort out many ideas and potential problems before you begin to paint, and this will probably mean less changes, and headaches, as the painting progresses. If you adjust the proportions of your sketch, by making it wider or taller, remember to ensure that your painting has the same proportions as your sketch.

DESIGNING THE PICTURE

Now you need to make sure that your design is as strong as possible. I would like to offer you just a few important elements to check before you begin to paint.

THE FOCAL POINT

The focal point in your picture is the main area of interest – thinking of a title for a picture as you view a scene will often help you to decide upon a focal point. It is also useful to remember that, visually, the eye is always attracted to strong contrasts of colour or tone in an image. Placing your focal point in the centre of your paper is sometimes rather too obvious. Dividing your picture into thirds is a simple, but effective, way of producing a more satisfactory design.

LOOKING AT SHAPES

This is a little more difficult and requires you to exercise a new muscle! If you have a garden view from a window, I would like you to look outside and try to forget for a moment that you are looking at shrubs and flowers. Instead, try really hard to simplify the scene into a series of simple flat shapes. You can do this by half-closing your eyes and squinting at the scene. If you do this properly, details will disappear and areas, or shapes, become more apparent. Look at

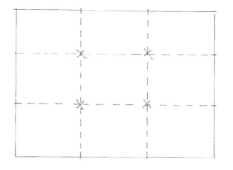

◀ *Any of these four points within the rectangle would be a suitable 'focal area' for a painting.*

▼ Golden Lilies
46 × 61 cm (18 × 24 in)
Brilliantly-coloured lilies nestling in a dark green border – apparently. In fact, the lilies were in flowerpots. I was able to arrange them exactly where I wanted them to give me a good composition. They are positioned approximately one-third of the way in from the left and one-third of the way down from the top.

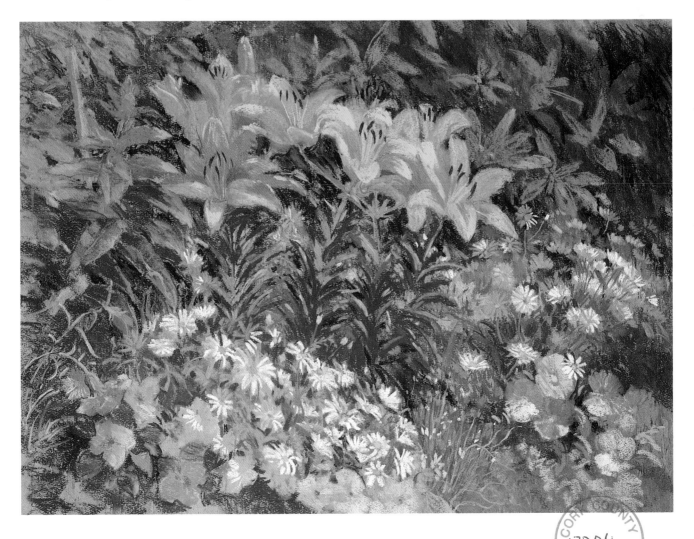

the sky shapes between tree branches and the shapes of the shrubs. Notice how masses of foliage knit together to form larger dark shapes.

LIGHT AND DARK TONES

The distribution of light and dark areas within a picture is very important if you want an attractive, lively result. Begin your thumbnail sketch in the way I suggest, with a light line drawing defining the main shapes. Then squint hard to simplify the scene into its main light and dark areas, considering whether you want more light, or more dark areas – a 50/50 balance may lack impact. Having decided where the lightest parts are, use shading to cover all the darker areas. This will establish the balance of light and dark areas. You can, of course, modify the tonal areas by adding more dark tones, but there is really no need to add details.

PERSPECTIVE

To create the illusion of depth in your garden you can overlap shapes, use changes in scale and perspective. Overlapping shapes and scale changes are reasonably easy to master but perspective is not. Badly drawn perspective will spoil every picture you paint, so be prepared to tackle this subject head on. Begin by determining your eye level (horizon) when viewing a scene. Sit up very straight, looking directly ahead of you, and then put your sketchbook on the bridge of your nose and look across it – this is your eye level! Make a mark on the paper to indicate where the eye level appears in your picture. (Of course, if you are sitting on the roof of your house, looking down at your garden, your eye level will be well above the scene and you would not be able to put marks on the paper!)

Now for the golden rules, which you need to commit to memory. All parallel lines above your eye level, running away from you, go down to the eye level. All parallel lines below your eye level, running away from you, go up to the eye level. In many instances, these lines will meet at a common vanishing point on the eye level line.

There is, of course, more to perspective than this. You need to study a good book on the subject, particularly if your paintings include, for example, tables and chairs, conservatories and potting sheds, trellises and fences, all of which require a basic understanding of perspective if you are to draw them correctly.

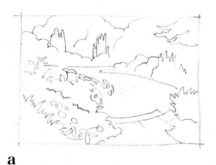

a

b

c

◀ *When you draw your thumbnail sketch (**a**), begin with a line drawing indicating the main shape areas. You can adjust shapes if you wish, perhaps emphasizing shapes which repeat or echo each other, since repetition creates harmony and rhythm; these elements are just as important in painting as they are in music or poetry. Then add tonal shading to everything but the lightest areas (**b**). Finally, add some more of the darker tones to give you a range from light to dark (**c**).*

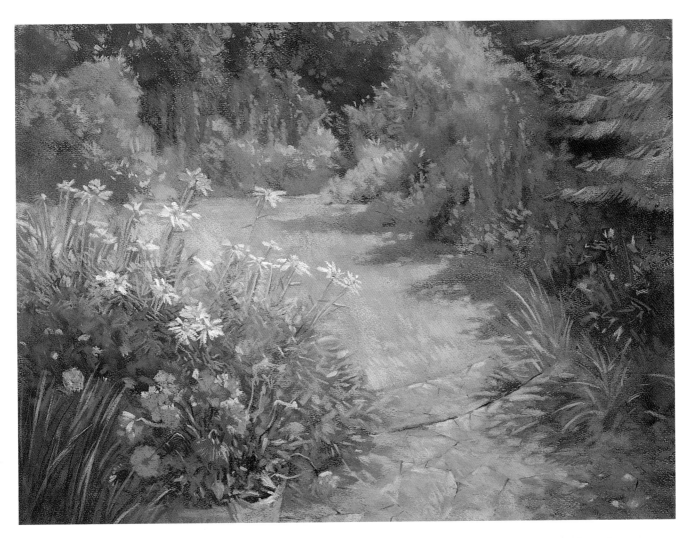

▲ Terrace View
38 × 53 cm (15 × 21 in)
I tried several thumbnail sketches before embarking on this view from the terrace; two landscape-shaped and two portrait-shaped ones. By selecting one idea, and rejecting others, you are making conscious decisions about composition. Drawing thumbnail sketches will also help to increase your confidence and allow you to 'warm up' for a painting.

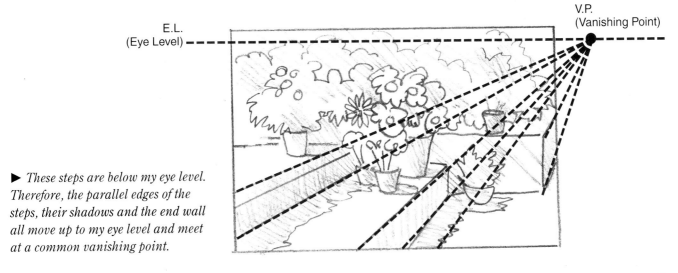

E.L.
(Eye Level)

V.P.
(Vanishing Point)

► *These steps are below my eye level. Therefore, the parallel edges of the steps, their shadows and the end wall all move up to my eye level and meet at a common vanishing point.*

23

COLOUR

If I asked you to describe the colour of a white flower, you could be forgiven for thinking dark thoughts about my intelligence. However, it would not have been a trick question, since the answer is, in fact, quite complex. In order to answer the question, you would need to ask some of your own. For example, is the flower outdoors, in direct sunlight? Are there shadows falling on to the flower? Is it sitting next to flowers which are very brightly coloured, so that it is reflecting some of that colour? As you can see, 'white' would be an inadequate answer, and this applies to every colour we look at.

THE COLOUR WHEEL

Since no two artists see colour in the same way, hard and fast rules about colour would seem to be unnecessary. One could also be forgiven for thinking that because a pastel painter does not need to mix colours, there is no need to be concerned with colour theory. However, as artists, we need a basic knowledge of colour in order to recognize colour relationships and to organize colours effectively in our paintings. Knowing the colour wheel, and understanding the language of colour, will help you to work out colour combinations which can be used to great advantage.

▲ *Why not copy this colour wheel into the back of your sketchbook? The three primary colours are red, yellow and blue. These are pure, unmixed colours. Mixing any two of these primary colours together will create a secondary colour.*

COLOUR TEMPERATURE

We all recognize that reds, yellows and oranges are warm colours, while blues, purples and greens are cool colours. However, it is important to realize that there are subtle 'warms' and 'cools' in all colours. A greenish-yellow, for example, is cooler than an orangey-yellow.

This knowledge can prove useful when we want to create certain effects in our paintings.

▼ *The top row shows cooler versions of each colour, warmer ones are positioned underneath. It is useful to be able to recognize when a colour is cool or warm, particularly when you are trying to be true to the type of light falling on your subject.*

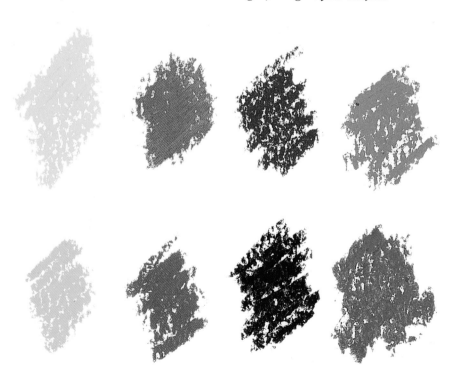

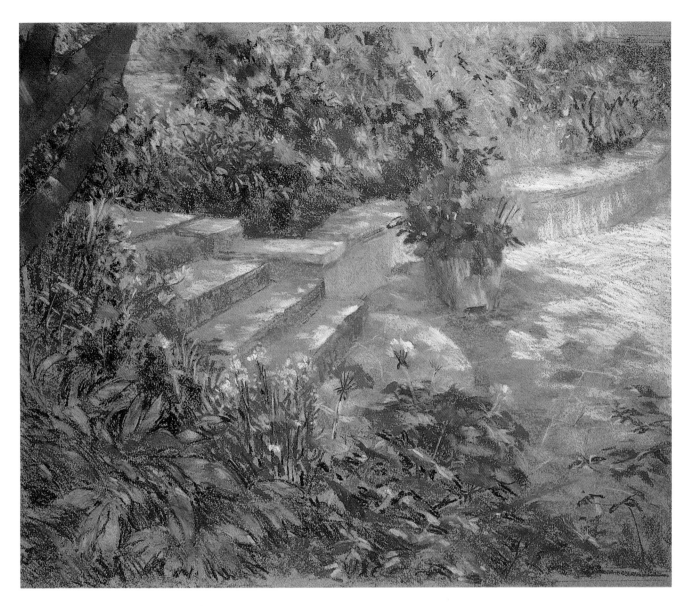

If, for instance, we want some yellow flowers to come forward in a picture, and others to recede, it may help to adjust the yellows in the picture, since warm colours tend to come forwards, while cooler colours recede. A red rose in warm sunlight, therefore, will have cooler, bluer reds on its shadow side than on its sunlit side.

We can also select our subjects carefully, bearing warm and cool colours in mind. To create an overall feeling of warmth, we need to select a scene with dominant warm colours. Cool colours can then be used as accents to intensify the warmer ones.

▲ Shady Patio
38 × 53 cm (15 × 21 in)
Complementary colours are used throughout this image. Warm and cool greens dominate the composition, while the reds are used as small striking accents. The soft, blue-grey shadows on the patio steps provide an area of relief from the stronger colours of the flowers and foliage.

COMPLEMENTARY COLOURS

I would like you to try a little experiment. Stare at the red shape (below) for about 30 seconds, then look at a piece of white paper or shut your eyes. You will see a green after-image. The reverse will apply if you try to same experiment with a green shape. This after-image is the complementary colour created by our brain.

Opposite each colour on the colour wheel you will find its complementary colour. This means that there are three main pairs of complementaries, each consisting of one primary colour and a secondary colour that is composed of the other two primaries mixed together.

In a painting, complementary colours can be used most effectively when used together as they contrast dramatically, vibrate and attract attention. A small area of red flowers in a large mass of green foliage will be particularly eye-catching – the red will enhance the greenness of the greens. It is exciting to learn about complementary colours and to begin to use them deliberately. The great Masters used complementary pairs frequently in their paintings.

▲ *These are the main complementary pairs, which, when used as the main colour key for a painting, can prove most effective. However, you need to be careful not to use equal quantities of each colour in one painting because this will be uncomfortable to look at. It is best to allow one of the colours to dominate, and to use varieties of that colour, including more neutral, greyish tones. The complementary colour can then act as a vivid and contrasting accent.*

COLOUR HARMONY

Colours alongside each other on the colour wheel – for example orange and yellow – are called 'analogous colours'. Used together in a picture they will produce colour harmony, as opposed to colour contrasts.

It can be an excellent discipline to work with a limited palette, and repeating basic combinations of analogous colours throughout a painting (shown right) will produce a very harmonious image.

▲ *The red shape test.*

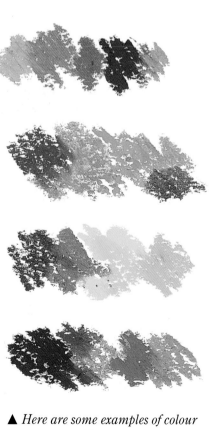

▲ *Here are some examples of colour harmony groupings.*

▶ Yellow Roses
30 × 36 cm (12 × 14½ in)
Here is a good example of an image where analogous colours, in this case yellow and green, dominate. There is just a hint of purple, yellow's complementary, to add interest.

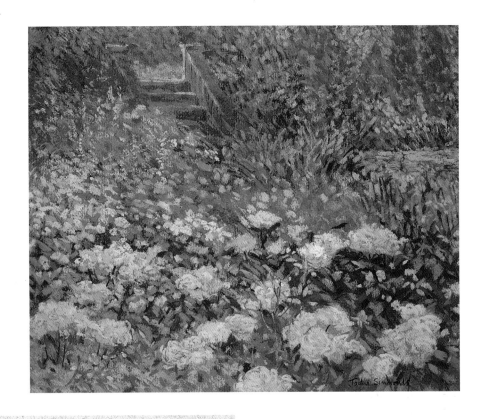

COLOUR AND TONE

This is confusing, isn't it! But it's really not that difficult to grasp, once you realize that 'tone' simply means the lightness or darkness of colours. Tone can be related to colours in two ways. The first aspect is the difference between colours – I am sure you realize that yellow is a lighter colour than purple. The second aspect, which sometimes confuses a beginner, is that tone is the lightness or darkness in each individual colour family. So, a pale Cobalt Blue is lighter in tone than a dark Cobalt Blue.

◀ *It's fun, and revealing, to make yourself a little chart to see if you can match colour tones accurately. Try one like mine, then photocopy it in black and white to see how well you've managed to identify the tones. It isn't as easy as it looks!*

HOW LIGHT AFFECTS COLOURS

Colours are always affected by light. A blue flower, for instance, can be seen in a variety of tones, from the palest blue where light strikes its petals, to dark deep blue in the shadowy areas. You can understand from this that you need to analyse everything you see in terms of tones. The ability to translate colours into correct tones is one of the painter's most essential skills.

Different times of day and weather conditions will affect the prevailing light, and can alter colours dramatically. Bright sunlight will cast a golden yellow glow on green leaves, while the same leaves, on an overcast day, will appear blue-green. As a general rule, it is best not to start a painting in the morning and expect to continue with it all day. The sun will move, shadows will change, and colours will alter frustratingly! Midday can prove to be a tricky time to work, since direct overhead sunlight tends to flatten forms.

If you cannot finish a painting in a morning, or afternoon, then it is best to return to it at the same time of day, and ideally when weather conditions are similar too! As you can imagine, this is not always as easy as it sounds, so it can help to take a photograph of the scene – you might then be able to complete your painting from it. A photograph is not always 'true' for tone or colour, so simply use it to jog your memory, rather than copying from it slavishly.

THE COLOUR OF SHADOWS

Sunlight inevitably casts shadows, and shadows in a garden scene can often be fascinating to paint. I love to paint lacy shadows and flickering light on stone patios and white walls. Shadow shapes will change quite quickly as the sun moves across the sky, so it is important to make a note of the shapes early on in your painting.

The colour of shadows will depend on the surface upon which they fall, and these colours are often far removed from

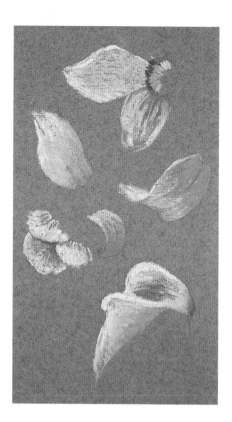

▲ *Shadows on white petals can be wonderful to paint because there are so many varieties of colour to discover! Cast shadows on white are often subtle shades of blue, or purple. Sometimes the shadows will have hints of yellow, or green, as the flower picks up colour from its surroundings, or from itself, as in the example at the top, where the petals reflect the golden yellow of the flower's centre. Using one shade of grey for all your shadows would look cold and uninteresting.*

simple grey. For instance, shadows falling on a white wall are often blue or violet; on a terracotta pot or red brick wall they may be rich dark chestnut, perhaps with hints of blue; on grass shadows will be blue-green, emphasizing, by contrast, the yellowness of the sunlit areas. Shadows on flowers will often contain hints of the flower colour's complementary – an orange flower's shadowy petals may have a blue cast; the shadow

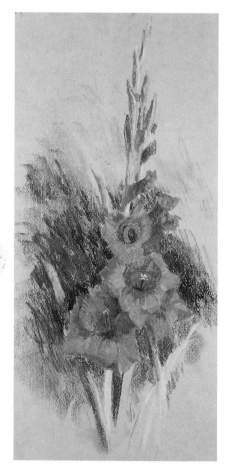

▲ *Light striking this red gladiolus provided me with an opportunity to examine the effects of light on colours. The light-struck parts of the petals varied greatly in colour; ranging from a warm light red, almost salmon-pink colour, to a richer deep red, with touches of brilliant hot orange-red in places. In the shadow areas, the reds were much darker, but also much cooler and more blue-red.*

side of a daffodil may have hints of purpley-bronze. Close observation of colour is the key. It will not only improve your paintings, but will enhance your enjoyment of nature generally.

PAINTING WHITES

White flowers immediately light up a garden, but if you pick up a white pastel to paint each one, your flowers will look surprisingly unrealistic and flat; the effect of bright light accents in the garden will be completely lost.

Begin by squinting hard and paint the shadowy parts of the flowers using subtle pale blues, lilacs and greens. Reserve your softest pastels in white and cream until the very end, then apply tiny touches where the light strikes and is brightest. It is also worth remembering that white itself is rather cold, and on a warm summer's day, using creams together with your whites will better say 'white in sunlight'.

▼ White Hydrangea
48 × 63.5 cm (19 × 25 in)
This glorious shrub was simply irresistible. The 'white' blooms varied subtly in colour – not only did they reflect colours from their surroundings, they also varied in colour in themselves. Some of the younger blooms were pale green; other more mature flower heads were creamy pink, or had pink edges. It was a joy to paint.

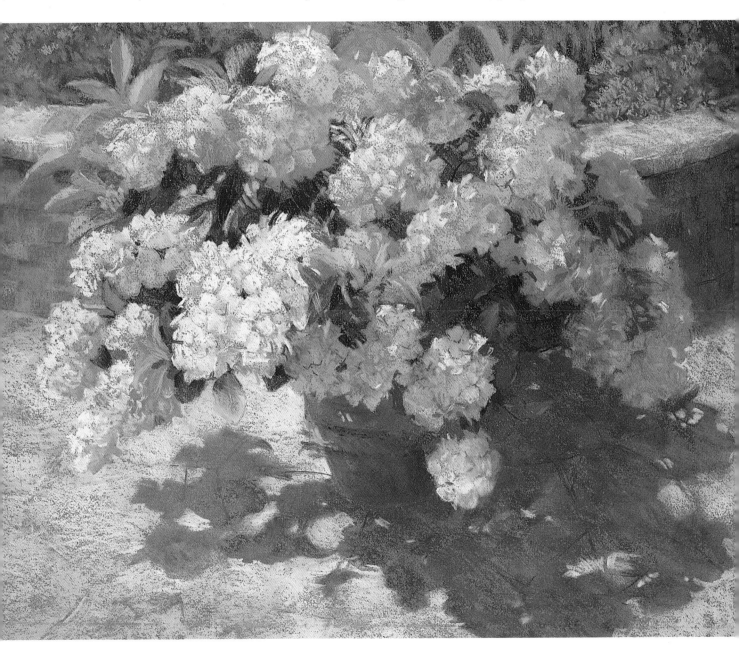

PAINTING FOLIAGE

Foliage in a garden can provide a cool, gentle foil to bright colour or it can be gloriously colourful itself. Not all foliage is green, of course. For example, some trees have wonderful dark red leaves and there are silver-grey border plants in my garden. As seasons change, so do colours. However, for most of the year, and in most of the garden, large areas of green dominate the scene, and this can be quite a challenge!

CHOOSING GREENS

The word 'green' is a simplification, since the greenery in a garden is varied in hue and tone. Not only are different plants and shrubs different kinds of green, but light also plays a strong part, providing us with a variety of green tones, from very pale to very dark.

It is important to realize that unlike other colours, there are very few natural sources of green pigment and, as a result, most green pigments are produced chemically. This means that some green pastels, while possibly useful for the occasional accent of colour, or for man-made objects in a garden, such as a painted chair or door, are rather vivid and artificial-looking when you use them exclusively for foliage.

Be careful when selecting a suitable range of greens. You need a good variety including some that look more 'organic'; yellow-greens, blue-greens, grey-greens and olive greens. It can also help to use other colours together with your greens for variety and interest in an area of foliage; warm reds or browns under your greens will help to suggest shadowy depths within a bush or shrub.

PAINTING INDIVIDUAL LEAVES

When you tackle small areas of flowers and foliage, or a still life with flowers, you will need to observe leaf shapes and colours carefully. Shapes will vary according to the plant, but you also need to notice how shapes change as leaves twist and turn – do be careful not to generalize too much and to create a mass of leaves which are all the same in shape, size and direction.

Also, beware of putting in every vein and nuance of texture unless you are producing a very detailed image – a botanical study, for example. A suggestion of veins may be enough to describe the shape of a particular leaf. You can sometimes pick out a vein or two using a tiny piece of putty eraser, shaped into a sharp point.

◀ *The greens on the left are rather bright and artificial – using too many of these in a scene will destroy any feeling of natural colour. The greens on the right, however, are more subtle and, as a result, more natural.*

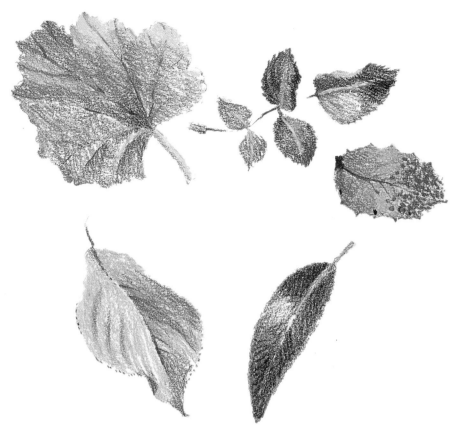

◄ *When looking at colours, notice how leaves that are in direct sunlight often have a yellow glow, which is different to the colour created when sunlight shines through a translucent leaf. Shadowed leaves can be dark blue-green; leaves facing the sky are sometimes palest icy-blue, reflecting the blue of the sky.*

▼ *This little study was painted in oil pastels on rough watercolour paper. The sun threw a warm light onto the largest bush, so it was painted with a mixture of yellow and green, with blues and dark greens for the shadow area. The conifers, which have a natural colour of dark blue-green, vary in tone from light to dark, and the small bushes are painted with touches of green, blue, orange and rust. The grass is cream, sharp green and yellow in the sunlit areas, while the shadows on the grass are a cooler, bluer green.*

FOLIAGE MASSES

When tackling foliage masses, the golden rule applies – squint! This will simplify a complicated mass into a simpler shape. From a distance, you cannot see individual leaves, so paint what you see, rather than what you know to be there.

You may find it easiest to begin with your darkest tones within the mass, and then you can gradually introduce middle tones and, finally, some lighter accents – of course, this will depend upon the way the light is striking the area you are painting. A bush, which has a round form, may have a light side, whereas a mass of foliage along a wall in shadow, may only have subtle middle-tones. Remember, the further away an object is from you, the less detail you need to include.

CHOOSING A SUBJECT

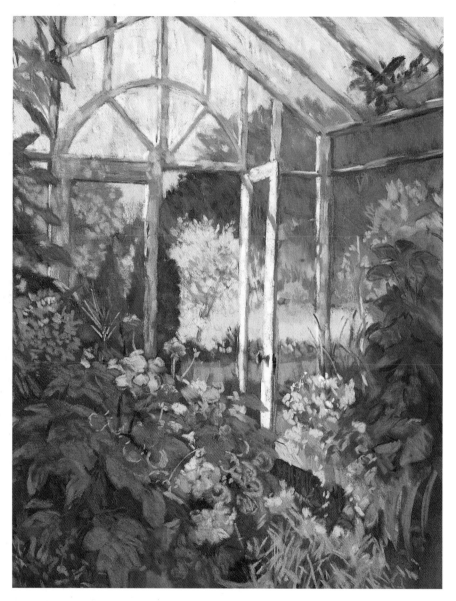

One of the nicest aspects of painting in a garden is that it presents the painter with an opportunity to practise working out-of-doors, in peace and privacy. There is no need to worry about curious onlookers, who may be well-meaning, but can make us, as artists, feel awfully self-conscious!

Also, if you have never worked out-of-doors before, you will discover that you need to learn how to deal with the challenges presented by sun, wind, changing light conditions, and even wildlife! You will also have to speed up – this may mean changing your usual approach to painting.

▲ The Conservatory
28 × 21.5 cm (11 × 8½ in)
You don't have to paint an outdoors garden every time if you can find a conservatory to work in! Here I was able to paint an indoor scene with hints of the garden beyond.

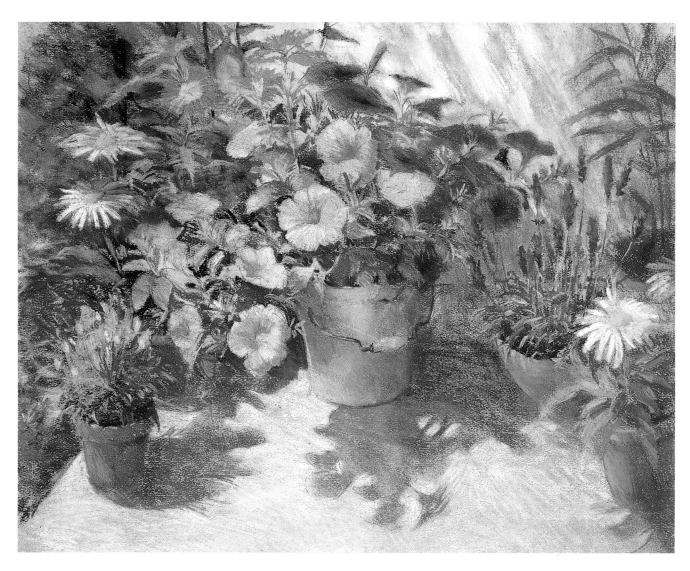

▲ The Green Bucket
46 × 56 cm (18 × 22 in)
It is always a good idea to look for
interesting props to use in the garden.
This lovely old tin bucket caught my
eye in a junk shop and is now one of
my favourite garden objects.

▶ Giverny, Springtime
46 × 56 cm (18 × 22 in)
If you decide to tackle an image like
this, remember to stop painting when
the sun moves round and alters the
light and shadows in the scene. It is
best to finish the picture on another day,
choosing the same time of day to work.

We often become over-familiar with our own gardens and begin to take them for granted, seeing only the weeds which need clearing or the lawn which needs cutting! You need to develop an 'artist's eye', discovering your garden anew, in order to find possible subjects.

Often, we fail to notice that simple, everyday objects, which are usually taken for granted, have a personality and beauty waiting to be discovered. Look again at overgrown corners – they may offer fascinating shapes to paint at certain times of day, particularly when the sunlight creates strong shadows and contrasts. When choosing a subject in a garden, remember to start with something reasonably simple. It can be just as rewarding to tackle a tiny corner, as it is to paint a large, busy, flower-filled garden scene – in fact, the result is, surprisingly, often more evocative.

If you are comfortable with indoor still-life painting, then I feel sure you will thoroughly enjoy setting up a garden still life, or selecting a 'found' still life of garden tools, furniture, or ornaments *in situ*. A hanging basket, for instance, is a form of outdoor still life!

Tiny patios, balconies and even window boxes can provide just as much inspiration as the largest of gardens – in fact, having a limited area to select from often makes choosing a subject much easier!

As well as painting your own, or your neighbour's garden, you can of course visit public gardens, or even private gardens which are open to the public at certain times of year.

You certainly do not need to paint the neatest or prettiest subjects in order to produce a good picture. Scruffy corners, broken flowerpots, rusty gates and weather-beaten fences can often provide fascinating shapes and colours. The resulting image may well have a marvellous sense of atmosphere and history.

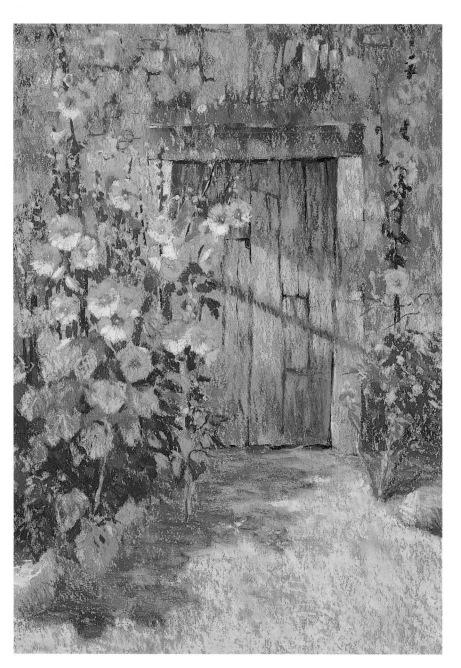

◀ Greek Door and Hollyhocks
48 × 34 cm (19 × 13½ in)
Flowers abound on Greek islands, often in unusual corners. I loved the way these splendid hollyhocks stood guard outside a rather dilapidated old wooden door, as if protecting something very precious. Do look out for images that fire your imagination!

► The Rusty Dustbin
30 × 28 cm (12 × 11 in)
This old dustbin had certainly seen
better days – but for an artist, even a
rusted old dustbin can provide a
delicious colour note among the
masses of greenery!

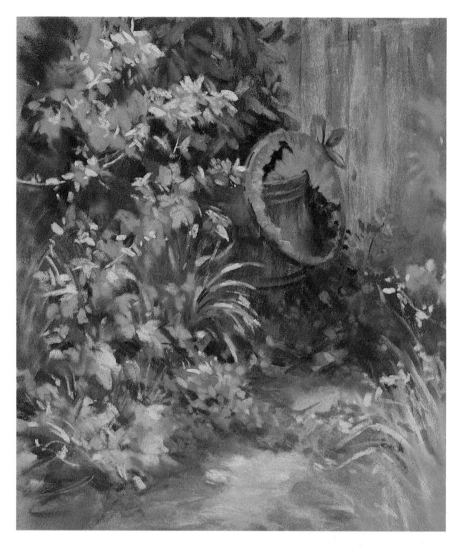

▼ Clematis
38 × 46 cm (15 × 18 in)
I used a dark blue pastel paper for this
image. The strong contrast of a dark
paper used for light-coloured blooms
adds sparkle and drama.

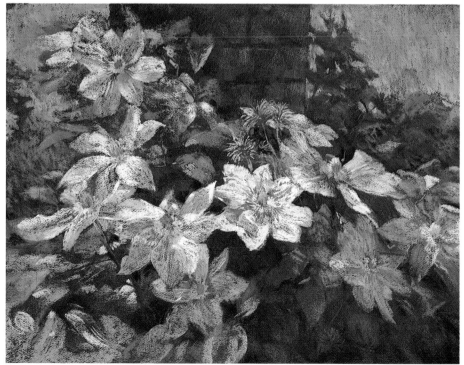

FLOWERS

It is all too easy to make flowers look fixed and lifeless when you paint them – yet flowers are short-lived, fragile, living and breathing things. They turn their faces to follow the light, sometimes straining joyfully upwards, sometimes drooping gently downwards. Their delicate petals may be floating and sinuous, or curving and tightly-packed. They can be chunky and opaque, or fine and softly translucent. How can we best re-create this transient beauty?

THE STRUCTURE OF FLOWERS

An understanding of a plant's basic structure is essential in order to capture its true character. Look carefully at your flowers before you begin to work and try to simplify their shapes in your mind – my little sketches show you what I mean. When you begin to draw, you could start with a simplified shape and then you could gradually define the structure. You need to check proportions as you work because these will change dramatically in relation to the position of the flower head. Look very carefully to see where to draw the centre of the flower, then imagine that the petals are transparent in order to ensure that the stem is in the right place. Small details like these, if neglected, will spoil all your hard work.

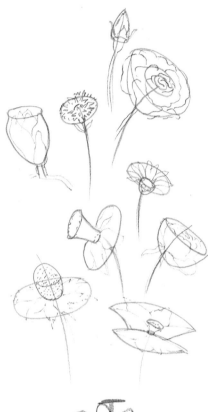

◄ *Simplifying flowers, by only drawing their basic shapes, is a good way to begin. If you use charcoal for your initial drawing, dust off most of the charcoal with a tissue. This will leave a faint shadow of the shape to contain a more careful drawing.*

◄ *Checking proportions will ensure that your flower heads looks correct. Circular flowers which turn away from you may be surprisingly wide compared with their height. Petals may also vary in size, depending on whether they bend towards, or away from you.*

◄ *This flower was carefully measured and the first marks I put on the paper were dots to show the height and width of the flower. Then I indicated the centre of the flower. Having established these points, I began drawing these wonderfully-shaped petals, working from the centre out to the edges of the plant. If you follow the stem 'through' the large left-hand petal, you can see that it meets the centre properly.*

PAINTING FLOWERS

If you try to paint every tiny detail, and give equal emphasis to the edges of every petal and leaf, your final image is very likely to look stiff and wooden – this is exactly what flowers are not.

The main elements to capture are the mass, or shape, of the flower, together with some indication of its basic structure. Probably of greater importance, look to see how the light falls on the flower – how it creates crisp sharp details in some places and softer, less-defined forms and edges elsewhere. You may have to look very hard to see these subtleties to begin with, but discovering them will pay enormous dividends.

It may also help to look for, and even exaggerate, rhythmic curving lines and forms to add movement and vitality to your picture, which in turn will suggest life and growth.

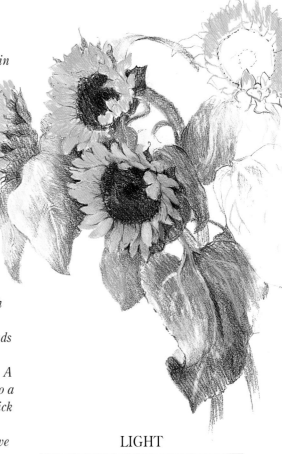

▶ *Pastel pencils were used for this study and the sunflower positioned in the top right-hand corner shows how I began to work. Dots were drawn to indicate the centre of the flower and then the petals were added. Rather than colouring in one petal at a time I simplified the colour masses, working across my initial drawing with yellows and oranges and finally sharpening up details with my darkest colours. The veins on the leaves were only suggested rather than painstakingly reproduced with photographic accuracy because I wanted to emphasize the flower heads – I felt that too much detail on the leaves would have been distracting. A tiny piece of putty eraser, kneaded to a point, can sometimes be useful to pick out veins on leaves. However, I recommend that you be very selective about how many veins you indicate; one or two lines may help to emphasize the curve of a leaf but too many could look horrible!*

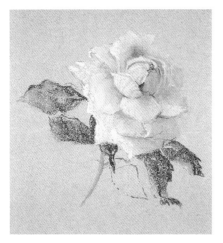

◀ *I began this study of a rose with a faint charcoal drawing, being careful to place the centre of the flower high on the right and indicating where the main points of the petals should be placed. I tackled the shadowed sides of the petals first with a dark tone and then added the medium and lightest tones, finishing off with just a few touches of dark brown pastel pencil to sharpen up the detail in the centre. Most of the lighter petals are fairly well-defined; others, such as the darker petals on the right of the flower, have softer edges that help them to recede and prevent the flower from looking too solid.*

LIGHT

When you are working indoors, directional light from a window or lamp can be carefully controlled. If you are working outdoors, however, you must remember that the light will be less constant; you will need to establish the patterns of shadows early on and remain true to the direction of the light as you paint.

CREATING DEPTH

The spaces between flower heads in a garden scene contain stalks and leaves. If you generalize too much and just paint 'green' in these spaces, you may flatten your image and destroy any feeling of depth. If you look carefully, you will be able to follow stalks through as they disappear behind leaves or petals and then reappear again – these overlapping forms will help to create a sense of depth in your image.

GARDEN TREES

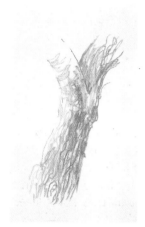 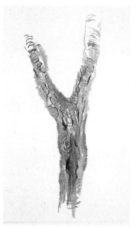

◀ *Tree trunks and branches seen at close quarters are seldom just brown in colour. Their textures and colours vary dramatically, as these quick pastel pencil sketches show.*

When painting trees in a rural landscape setting, you would usually see the whole tree in the middle distance or a group of trees in the far distance. Painting trees in the garden is an entirely different matter since, particularly in smaller gardens, one seldom sees the entire tree shape unless it is a very young, small tree – far more of the trunk of the tree, its individual branches and, of course, its foliage is visible.

TREE TRUNKS

Tree trunks provide us with a marvellous opportunity to capture texture and colour because bark varies enormously from tree to tree. Also, study how the trunk meets the ground – the base is often the widest part of the trunk and the roots, if close to the surface, can sometimes create interesting bumps and hollows in the ground.

It is important to develop the 'roundness' of a tree trunk. Careful observation of directional light will help but you can also suggest the form with judicious use of the occasional descriptive line. Pretend you are a little insect crawling around the tree and, using the edge of the pastel, draw the path such an insect would take! At eye level, lines will be horizontal; when looking up the trunk, lines will arc upwards; and looking down the trunk, your lines will dip as they curve.

▶ *Notice how each branch sends out another branch that is smaller in diameter, culminating in the tiniest twigs at the outer edges of the tree. Because trees in the garden are seen at close quarters, it is important to observe and draw them carefully and accurately rather than to generalize their shapes.*

BRANCHES

Perhaps the most important thing to notice about tree branches is their pattern of growth. Most people assume that branches simply taper from thick to thin. This is not strictly true, as my drawing demonstrates. You may find it useful to try a drawing like mine. As you work, look to see if the bark wraps itself around each branch – this effect provides very helpful lines to describe the form. If the bark runs along the

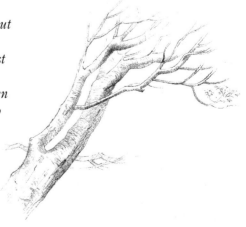

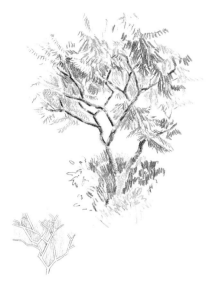

◀ The small pencil diagram shows how the negative shapes between the branches are similar in character; each small shape echoes the largest central diamond shape.

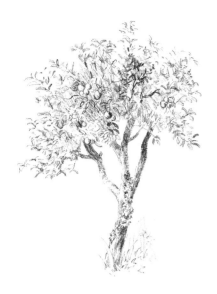

▶ Brown pastel pencil was used for this study of an apple tree. The foliage is tackled loosely but, nevertheless, some leaves are drawn more carefully in order to describe their essential curving character. Notice how the trunk and branches are darker under the foliage – here, less light strikes the bark.

length of the branch instead, then you may need to emphasize the way the light strikes the branch from above in order to give a better impression of the form.

When drawing branches it may help to look hard at, and even draw, the spaces between them, rather than the branches themselves. These spaces – called negative shapes – are often interesting in themselves, while at the same time defining the branches for you. You may find that they provide a useful repeating pattern that will make for a strong composition, particularly if you can find similar shapes elsewhere in the picture – a 'family', if you like, of similar shapes will reinforce the image's underlying secret geometry.

▶ Garden Pear Tree
51 × 46 cm (20 × 18 in)
This garden pear tree is sunlit from the left, which helps to describe the form. Look carefully at the lines describing the 'bandages' on the two central trunks. On the left-hand trunk the lines dip and on the other they arc upwards. This is because the left-hand trunk leans towards us and the right-hand one leans back towards the hedge.

FOLIAGE

Foliage will also vary according to the tree type and the season. Half-closed eyes will help to mass full-blown summer foliage into paintable shapes, and careful observation of a few leaf shapes at the outer edges of a clump of leaves will define the character of the tree.

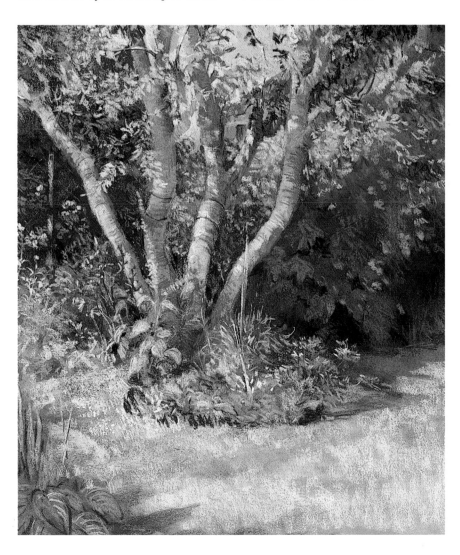

SIMPLIFYING NATURE

When you glance at a garden, you initially absorb an impression of the scene and its atmosphere – lots of soft greenery, vibrant colour in places, texture and movement. You feel the warmth of the sun, or perhaps the dampness of recent rain and you breathe a mixture of fragrances. If you then sit to draw or paint, you begin to observe more carefully, your eyes resting far longer on each tiny detail.

Although some artists relish highly detailed work, there are also those who do not want photographic accuracy. Instead, they wish to capture that first general impression, which, if achieved successfully, can sometimes be more visually satisfying in terms of softness, atmosphere, life and spontaneity.

VIEWING THE SCENE

In order to simplify what we see, we need to learn how to look at our subject. As I have suggested earlier, the best way to do this is to look at your scene through almost-closed eyes – details disappear and the scene melts quickly into large, simple areas of shape and colour.

It can be difficult for a complete beginner to let go of the desire to faithfully render every flower and leaf accurately, so I recommend that you be prepared to practice. Choose a small corner of your garden and then try some loose impressions of your subject. Group areas of foliage into simple large shapes and simplify leaves and blooms into dots and dashes of colour. You will eventually find your own language of marks which will suggest the complexity of nature. Giving yourself a limited time period within which to work often helps!

A good idea is to study the garden paintings of the Impressionists. In them, you will

▼ I used pastel pencils on white card for this small 'garden impression'. Leaves and flowers are only suggested with a variety of dots, dashes and scribbles, leaving much to the imagination; yet these marks can be readily translated into a lively textured garden corner.

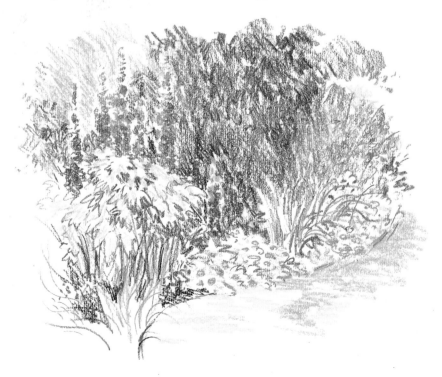

Tip

● If you cut mounts for your pictures from mount card, don't throw away the centre piece. Mount card is excellent for pastel drawings, particularly for use outdoors, since you will not need a drawing board. Picture framers are often happy to give away these off-cuts of card. White, or pale-coloured card, can be tinted with watercolours or acrylics. If you like a rougher, more textured surface, you can paint the mount card with one or two coats of Daler-Rowney Texture Paste, which grips pastel very well.

see how areas of flowers are simplified into banks and drifts of colour, shapes only suggested, but still sufficiently recognizable.

SIMPLIFY THE COLOUR

A riotous border of multicoloured flowers may be a joy to behold in the garden, but if you try to reproduce it exactly, not only will it be extremely difficult to compose, but the finished result is likely to look rather chaotic, and possibly even psychedelic!

Try to view your garden with a discerning eye and plan your picture by deciding on a colour theme, using colour harmonies or complementaries. Then simply leave out, or play down, any colours which are not appropriate or helpful. Remember, you are an artist not a camera, so you can edit as you work!

▲ *On a piece of watercolour paper I began with a multicoloured watercolour wash, using pink at the top and blues and greens at the bottom. You can see how the texture of the paper helps to break up the pastel marks, resulting in a convincing impression of foliage.*

▼ *This is a detail from a larger painting and it shows how simply the foliage and flowers are treated. Despite the fact that the flower heads are painted with just a few simple strokes of colour, it is still quite easy to identify the flowers.*

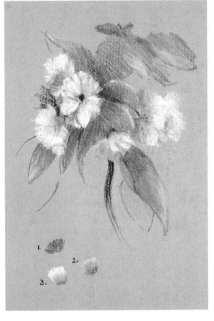

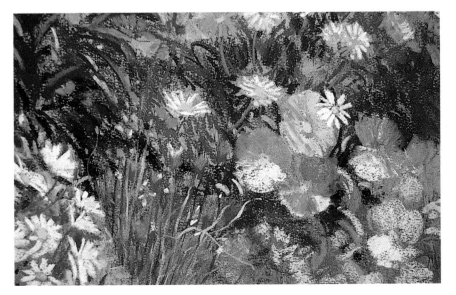

▲ *Just three pink pastel pencils were used for the petals of this cherry blossom. I began with the darkest pink, stroked on the medium tone and, finally, finished with the palest pink. All the flowers, except for the one on the right, which is painted in more detail, are simply suggested to capture the characteristic softness of these small flowers.*

GARDEN STILL LIFE

The phrase 'garden still life' seems rather a contradiction in terms, doesn't it. After all, there is constant life, growth and movement in a garden and the term implies a set-up which will not move or change as you paint it! However, any still life which contains live, growing plants or flowers cannot be relied upon to stay still for long. Even inanimate garden objects such as wheelbarrows, pots, steps and statues will change visually when light conditions change.

What does this mean for the painter? A simple phrase sums it up – 'speed is of the essence'. Luckily, with pastels, it is possible to complete a picture far more quickly than with most wet mediums. Forethought is essential for speed. I find that if I have planned well, and my thumbnail sketch 'works', then the picture can be completed fairly quickly.

▲ *Small individual studies of garden features like these can often provide ideas for paintings.*

◀ Lilac Basket
30 × 43 cm (12 × 17 in)
A still life need not be complicated. This garden trug of lilac and cherry blossom placed on the terrace, together with sunshine and shadows, made a simple but lovely composition.

SETTING UP A STILL LIFE

If you decide to set up a still life on a sunny day, study the sun and decide which way it will move. Make sure that you will have at least two or three hours to work before the sun moves away and your still life is thrown into shadow. An overcast day, or a shady spot, will give you longer to work but you will sacrifice the drama and design potential of light and cast shadows.

Keep to a simple colour scheme and choose your objects with their shapes in mind – a series of similar, echoing shapes, varying in size, will strengthen the picture's composition. Try to overlap objects in places to encourage the viewer's eye to move effortlessly from one part of your picture to another – too many spaces between objects means that the eye has to jump from one spot to another.

THE 'FOUND' STILL LIFE

Alternatively, you may prefer the idea of a painting which looks rather more natural and uncontrived. Your garden may offer more of these ready-made subjects than you imagine – you can find them by prowling around with a viewfinder in hand! Suddenly, that overgrown plant in the big square pot in a scruffy corner, with the rake leaning against it, looks totally different when seen through a viewfinder – the 'edges' of the rectangle magically give you an instant impression of a finished picture.

A few minutes spent on a thumbnail sketch will help you to decide upon the best composition. If you make a careful note of the shapes of any shadows in the

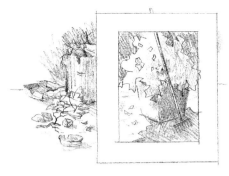

image, you will be able to refer to your sketch while you work and you will know when the shadows have changed so much that it's time to put down your tools!

◀ *Here the viewfinder isolated a potential composition from an unpromising corner.*

▼ Lilies by the Blue Door
53 × 38 cm (21 × 15 in)
This is an example of a 'found' still life. The lilies stood patiently on the terrace, waiting for me to position them for a painting. On impulse, I decided to leave them just where they were because I rather liked the contrast of the blue door behind them and the bright orange colour of the pots.

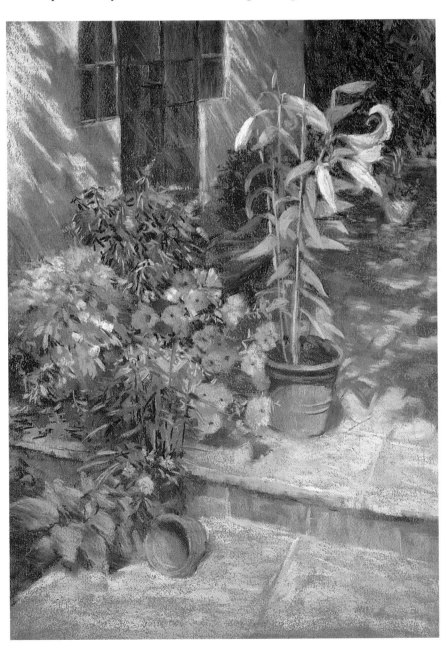

TERRACOTTA POTS
DEMONSTRATION

Painting a still life in a garden is a lovely way to begin painting outdoors. There is something quite comforting about tackling a small corner of a large scene. Also, you can choose and arrange the elements of the composition to suit yourself – this helps to build confidence. If you decide to try something similar, do be careful of the ellipses when you draw your flowerpots. Remember, when you look down on a pot and draw it, the base will curve slightly more than its lip, even though it is on a flat surface!

COLOURS
Hooker's Green 8; Purple Brown 6; Terre Verte 5 & 8; Indigo 4; Vandyke Brown 8; Sap Green 3; Blue Green 5; Cadmium Red 6; Cadmium Yellow 4; Yellow Ochre 0 & 2; Burnt Sienna 2 & 6; Cobalt Blue 2.

PRELIMINARY SKETCH
Looking through a viewfinder will help to isolate a potential composition from its surroundings. Then, if you spend a few minutes producing a quick thumbnail sketch, it will help you to feel much more confident about your final composition. The red arrows show my thought processes about this composition. I positioned the flowers in one of the rectangle's focal areas. The edges of the stone steps, the shadows and some of the surrounding foliage help to direct the viewer's eye to this spot.

▲ *Preliminary sketch*

FIRST STAGE
On Slate Grey pastel paper, I lightly drew the main elements of the image in charcoal.

I indicated my eye level and then I made sure that the lines of the steps met at a common vanishing point on the eye-level line. The vanishing point was outside the rectangle – I knew it would be, once I had done my

▼ *First stage*

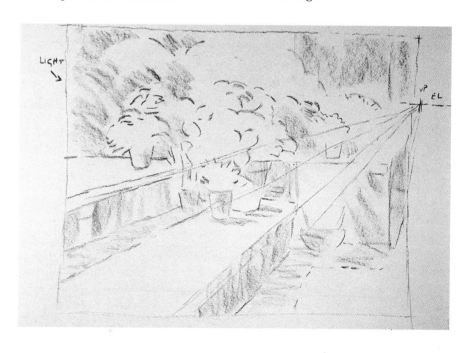

44

thumbnail sketch – so I left a margin for this very reason. It is usually a good idea to leave a margin anyway, so that you can test colours in this space.

Using side strokes of charcoal, I roughly indicated some of the darker parts of the composition. This was not strictly necessary because the charcoal would be covered with pastel. However, it can be helpful.

SECOND STAGE

I dusted off my perspective lines with a tissue and then began to use colour, starting with my darkest tones. Hooker's Green 8, Purple Brown 6, Terre Verte 8 and Indigo 4 allowed me to create lots of variety in these dark areas. I used a very light touch, with a mix of side strokes, and tiny lines for broken colour, in the background foliage area. I then blended a little of the colour on the steps with my fingers. I looked at my work critically and decided that I needed a few dark accents. I used Vandyke Brown 8 for small marks that added warm depth and gave some definition to the flowerpots.

THIRD STAGE

Using Sap Green 3 and Terre Verte 5 for middle tones in the foliage, I used short side strokes for broken colour throughout the image. I tried to keep the background softer than the leaves in the plant pots, so that it receded slightly. Small strokes of Blue Green 5 suggested leaves of a different, cooler hue on one of the background bushes. I used Burnt Umber 6 for the darker sides of the flowerpots, carefully crosshatching the strokes in a fairly loose, open manner to allow some of the under-colours to show through.

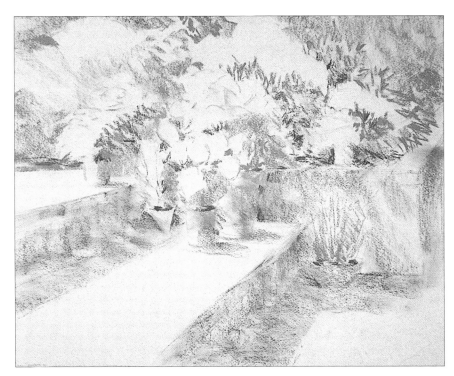

▲ *Second stage* ▼ *Third stage*

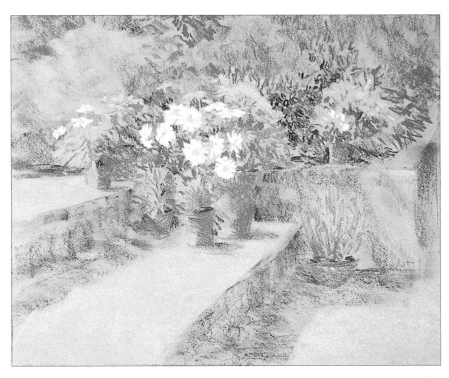

I decided that I needed to position some of the flower heads. Their bright tones would help me to decide if the tones I'd used so far needed adjustment. I used Cadmium Red 6, Cadmium Yellow 4 and Yellow Ochre 0 for the white flowers. Burnt Sienna 2 was then gently stroked over the sun-washed steps, since the grey of the paper is too cool and misleading. I believe it is best to slowly build up your whole image in this way, pulling it together gradually rather than completing one tiny piece at a time.

FINISHED STAGE

The white flowers were too uniformly bright, so a little Cobalt Blue 2 was added to the petals in shadow. Dots of the same colour suggested the tiny flowers of the lavender plant. Burnt Sienna 6, together with the tiny strokes of Cadmium Yellow 4 used for the flowers, lit up the sunny sides of the flowerpots and the yellow illuminated the red flowers, too. I added a few more red flowers, since I rather liked this little focal area and wanted to emphasize it.

I added Burnt Sienna 2 rather more positively to the patio wall, together with tiny lines of dark brown to suggest the brickwork. I stroked Yellow Ochre 2 (sunshine!) over the patio steps quite lightly so that some of the warm pink and the slate grey of the paper showed through the overpainting, hinting at the texture of the stone patio. The same colour was used on the occasional stem and leaf until, finally, I realized that I was fiddling, so I stopped painting!

▼ *This detail shows how the pastel has been applied quite simply; the foliage and flowers are painted with small linear strokes and broken colour, while side strokes of pastel have been used for the stone of the steps and wall. The grey of the paper shows subtly through the pastel marks throughout, indicating that I used a light touch with little overpainting.*

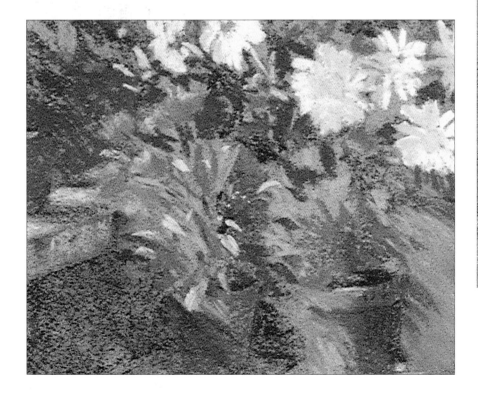

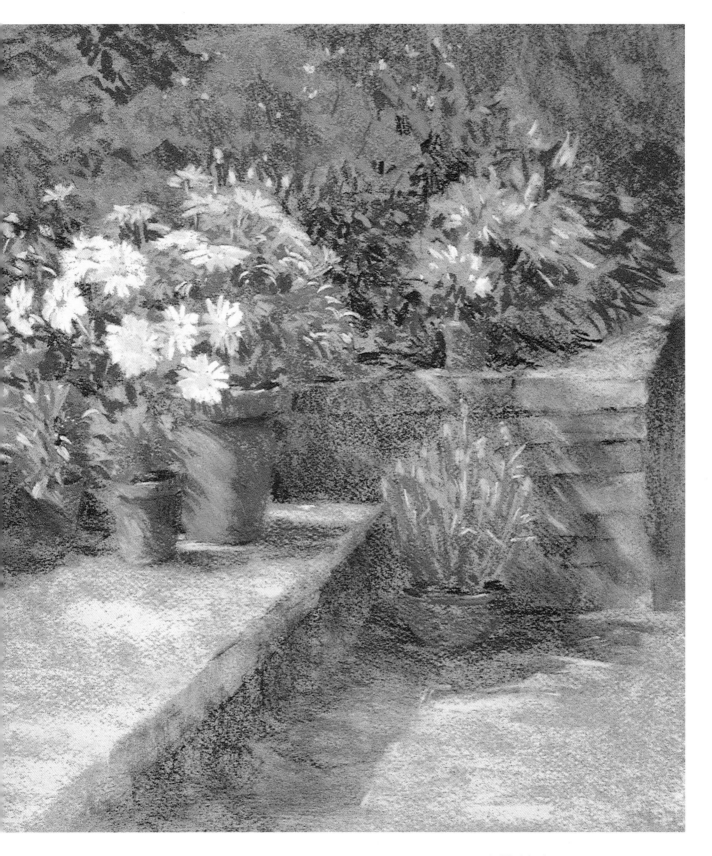

▲ *Finished stage*
Terracotta Pots
35 × 43 cm (14 × 17 in)

GARDEN LANDSCAPES

I know that many students approach the idea of painting a garden scene with great enthusiasm. After all, what could be nicer than painting in a garden, surrounded by nature's magnificence, feeling the warmth of the sun and enjoying the subtle fragrances of the flowers and freshly-mown grass?

However, that initial enthusiasm can diminish with the reality of painting unruly tangles of foliage, masses of colour, complex shapes and changing shadows. So, before starting, some careful thought and organisation is needed in order to maintain your enthusiasm and enjoyment!

In my garden, the flowers seldom grow exactly where I want them to for drawing and painting purposes. It can be very annoying when, for instance, lovely golden lilies, which glow in sunlight, are in the shade all afternoon. I overcome this problem by having potted plants, which I can move around the garden to provide colour in the right place at the right time.

CHOOSING A SCENE

I recommend you study your garden with a viewfinder firmly in hand, searching out possible compositions and making careful notes of the best times of day to paint. Midday can be quite a difficult time because overhead sunlight tends to flood the scene, flattening forms. Early morning, or afternoon sunlight, will offer more interesting contrasts of light and shadow. It is, of course, perfectly possible to paint on overcast days but you may need to seek out colour contrasts, rather than light/dark contrasts, to make your image exciting.

A flower-filled border can look glorious to the eye but do be careful to look for simple areas in your composition to relieve, and contrast with, the busy ones, such as an area of lawn, a fence or a patch of wall behind the profusion of flowers. Firm straight lines in the form of garden stakes, trellis work, containers or arbours can also help to provide a kind of scaffolding for the curving forms of leaves, petals and stems, and

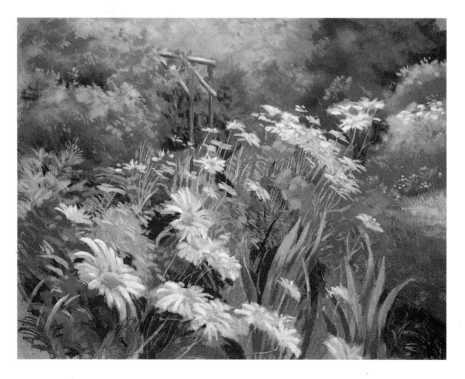

◀ Daisy Garden
48 × 61 cm (19 × 24 in)
Daisies in a garden are so dramatic, their sparkling white petals contrasting sharply with rich green foliage. I sat up close to the flowers, perched precariously on a small stool, and the nearest daisy heads loomed large, right in front of my eyes! I simplified the background greenery into soft drifts of colour, blending my initial strokes with a fingertip. I then added dots and dashes to suggest leaves on the left-hand side; some dark against light, others light against dark. Rhythm and movement are helped by the curving forms of leaves and stems; recession is achieved by a change of scale together with overlapping forms.

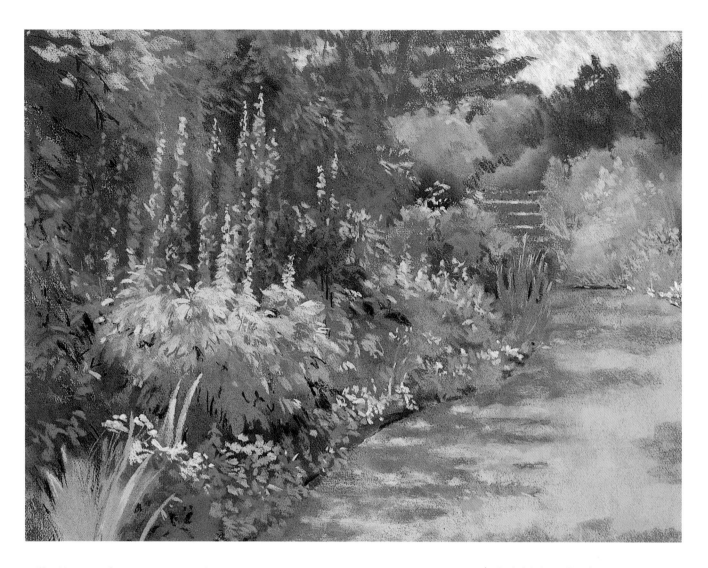

will offer a welcome contrast for
the eye to settle upon.

Where there are no obvious
paths to lead your eye back into a
scene, depth can be implied by
the use of overlapping forms, and
changes of scale from foreground
to background, not only in the
plants and foliage, but also in the
type of marks used to describe
the scene. My demonstration
painting on page 52 shows what I
mean by this.

I firmly believe that spending
ten minutes on one or two
little thumbnail sketches of
possible compositions, doing
your best to simplify the scene
into its main large shapes, and
light and dark areas, will be of
enormous benefit.

▲ Delphinium Garden
45 × 55 cm (17½ × 22 in)
*The looseness of the pastel marks helps
to maintain an impression of softness,
and although the flowers are not
painted in an accurate, descriptive
way, I'm sure you can still recognize
the delphiniums! The eye is led along
the edge of the lawn, gently past the
riotous border, to the steps at the back
of the garden, providing an interesting
secondary focal point.*

GARDEN VIEW
DEMONSTRATION

In order to paint this scene, I had to position myself behind, and close up, to the flowers. This is a lovely way to paint a garden – it made me feel as if I was growing in the flowerbed! It can be worthwhile to spend a little time looking carefully around your garden with a viewfinder in hand, in order to find interesting, less predictable viewpoints. If you do this, remember that if you stand and look through a viewfinder, but then sit to paint, the view will alter dramatically. If you do sit to paint, remember to stand up occasionally to view your painting from a distance.

COLOURS
Terre Verte 5 & 8; Prussian Blue 3; Indigo 4; Blue Green 4 & 5; Viridian 6; Vandyke Brown 6; Sap Green 3; Cobalt Blue 2; Yellow Ochre 1, 2 & 6; Burnt Sienna 6; Burnt Umber 3.

PRELIMINARY SKETCH
The curving forms of the daisies sweep through the garden, from the large forms in the foreground to the smaller shapes in the background. When a composition is full of curves like this, it helps to have something in the picture to hold the eye within the rectangle. Here, the horizontal line of the back edge of the lawn and the tree on this line provide this contrast. As a result, the curves are halted and the viewer's eye is gently directed back again towards the flowers.

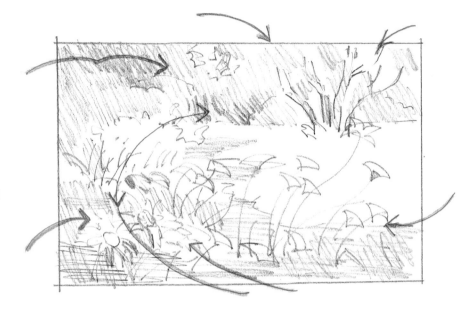

FIRST STAGE
On a warm raw umber-coloured sheet of pastel paper, I sketched in the main elements of my scene

▲ *Preliminary sketch*

▼ *First stage*

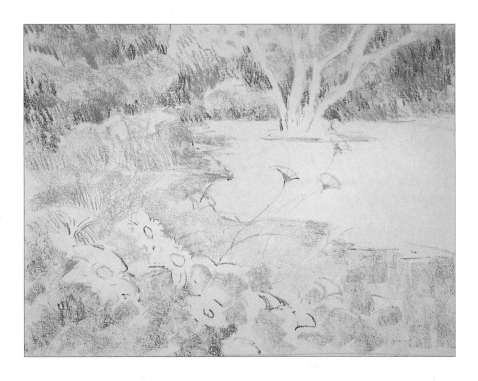

50

in charcoal and then began to use side strokes of pastel to indicate the darkest areas of the image. I used both blues and greens for variety – Terre Verte 8, Prussian Blue 3 and Indigo 4. I kept my touch very light because I know that if I press too hard in the early stages of the painting I will fill the tooth of the paper too quickly – I will then be unable to build up colour areas successfully. I stroked tiny lines of Blue Green 4 and Terre Verte 5 over my side strokes, making sure that I kept the image loose and open.

SECOND STAGE
I added small strokes of Blue Green 5 and Viridian 6 to the foliage areas, and Vandyke Brown 6 to the tree trunks. While I had this dark pastel in my hand, I also added a few dark strokes to the foreground. Sap Green 3 and Blue Green 5 were used for the lawn area, once again using light side strokes to allow some of the warm colour of the paper to show through the pastel. I used my fingers to blend some of the pastel to give me denser colour areas in places.

THIRD STAGE
Using Cobalt Blue 2, I added sky shapes at the top of the picture and, with the same colour, I used dots of pastel to suggest the drifts of daisies. This colour would perfectly represent the cool shadow colour of the white petals. Moving down the picture into the foreground, the heads of the daisies were drawn more convincingly. I was particularly careful to vary the shapes of the flowers – some are seen full-face while others turn away from me. Occasionally, individual flowers group together to create interesting shapes. I used

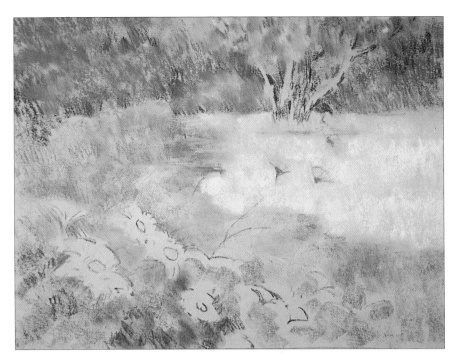

▲ *Second stage* ▼ *Third stage*

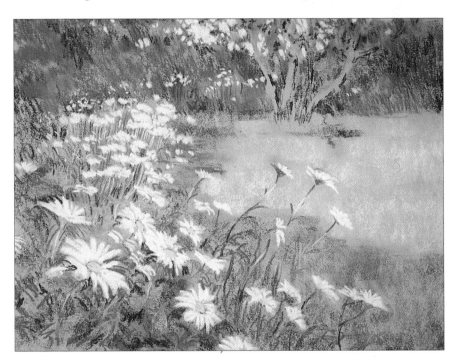

Yellow Ochre 6 for the flower centres. Then, using all the greens and blues I had used before, I employed a variety of short curving linear strokes to suggest the tangle of leaves and stems. Stabbing marks of my darkest blue added depth to the foliage throughout.

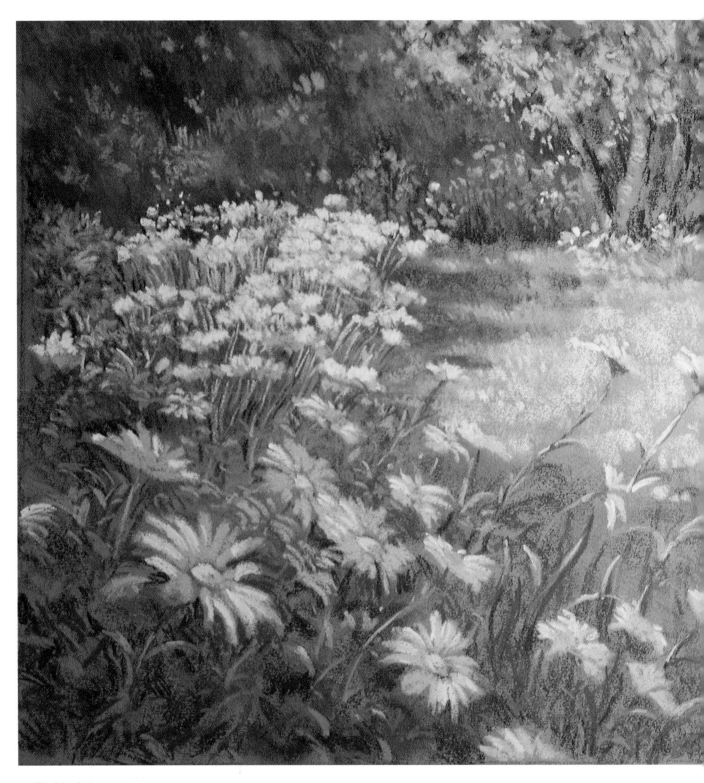

▲ *Finished stage*
Summer Daisies
34 × 47 cm (13 × 18½ in)

FINISHED STAGE

Now I began to introduce my lightest tones, which I hoped would bring sunlight to the scene. Yellow Ochre 2 lit up the left-hand side of the flower centres and Yellow Ochre l, which is in fact palest cream, was perfect for the sunlit parts of the white petals. Sap Green 3 was used to suggest brighter leaves in the foreground and the sunnier clumps of leaves on the tree. Strokes of the same colour, together with Yellow Ochre 2 and 6, were used for the warmth and texture of the lawn. The lighter parts of the tree trunks were painted with Burnt Umber 3, together with tiny touches of Yellow Ochre 2.

Nestling among the daisies was a feathery rust-coloured plant and Burnt Sienna 6, together with Yellow Ochre 6, added lively warm colour contrasts to the cool shadowy undergrowth. I used these same colours in the tiniest of touches at the base of the tree to draw the eye from the foreground to the background. Finally, I worked across the whole image, gradually adding small strokes of colour here and there until I felt that any more marks would be superfluous!

▼ *Notice how depth is created in this fairly simple scene by the change of scale from foreground to background. Flower stalks appearing between, and behind, flower heads also help to explain depth. Their curving forms, exaggerated and repeated, add to the overall feeling of life and movement.*

THE WATER GARDEN

▲ *Tiny horizontal lines over downward strokes suggest surface eddies on calm water.*

▲ *Reflections are usually distorted and 'broken up' by water shapes. They have soft edges, too.*

▲ *Short stabbing marks that diminish in size, and close up gradually, help to create a sense of recession.*

▲ *Warm colours for shadowy depths were finger-blended. Sky reflections were then added on top.*

▲ *Here, horizontal linear strokes suggest fine ripples and provide a sense of recession.*

▲ *Sometimes water will reflect unexpected colours – look hard and be bold!*

Water features in a garden are usually a strong focus and a source of much pleasure. The stillness of a reflective pool evokes peace and calm, while waterfalls and fountains are not only visually exciting but sound refreshing on a warm summer's evening. I am lucky enough to have more than one pond in my garden. In-between painting sessions, I find it wonderfully relaxing to watch the fish drift lazily between the feathery green fronds of water milfoil, while brightly-coloured dragonflies hover over the lily pads.

STILL WATER

Still water will generally reflect its surroundings. The most important thing to notice is that colours are muted; darks are lighter and lights are darker. For instance, light green reed stems will have darker green reflections. Also, if the water is clear and shallow, you may see patches of light, or shadows, on the bottom of a pond. These areas of colour will have much softer edges than any surface reflections and you can blur the edges of your shapes by rubbing them very gently. However, do make sure that your tonal values are correct and remember to look carefully for some indications of the water's surface – small marks suggesting tiny eddies will help to explain transparent shallow water.

MOVING WATER

Moving water is extremely elusive and presents the painter with a great challenge that is very satisfying to conquer! Observation is the key. Begin by simply watching the bubbles and ripples for a time and try to establish a pattern in your mind. Eventually, repeating shapes will present themselves to you. Practice drawing regularly in a sketchbook and you will

▲ *Here, circular ripples suggest water movement.*

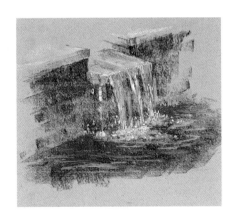

▲ *The dark wall was painted first, using the sides of the pastels, and then downward strokes of pale blue were used for the water cascade and bubbles. I highlighted the blue water and the edge of the ledge using a white pastel. I even used a sharp green in places, reflecting the colour of nearby foliage. Small broken strokes of red suggest large Japanese Koi in the water, and also imply depth.*

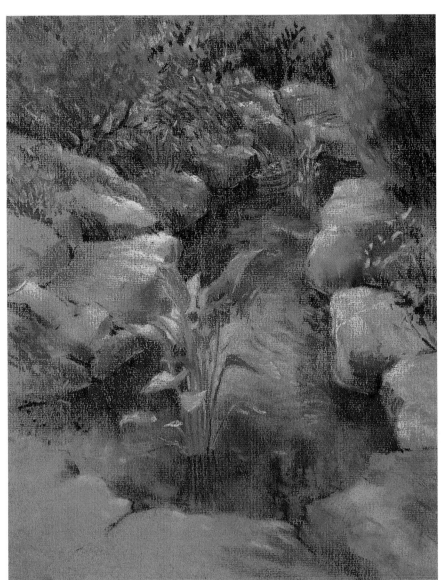

soon find you gain confidence as you gradually build up a vocabulary of marks to describe what you see.

Try to simplify your treatment of water as much as possible. Too many shapes, lines and frothy white foam may result in busy overstatement – it is best to try to 'say' the maximum amount with as few marks as possible. Please don't paint ripples carelessly as a series of random squiggles, hoping for the best. Look hard, identify a few, and paint some of what you see. Hopefully you will find my illustrations useful, but do try ideas of your own as well.

▲ Secret Rock Pool
38 × 30 cm (15 × 12 in)
Sunlight flickers on the leaves and rocks, and a small area of sky is reflected in the water. Also notice the ripples caused by trickles of water entering the pond between the rocks. Tiny stabbing marks were used for the foliage; the rest of the image was painted with side strokes of pastel using a light touch with very little blending, to allow the colours to mix visually. Notice how the reflections of the rocks are darker than the rocks themselves, as are the reflections of the reed stems.

WATER-LILIES
DEMONSTRATION

A particularly appealing aspect of a garden pond is often its attendant water plants. I decided to paint my water-lilies, trying hard not to feel intimidated by thoughts of Monet! I chose a close-up view of the corner of the pond nearest to me, where a large, brilliant water-lily floated near the reeds. Such a close view would also give me a chance to study the lily pads and allow me to paint them fairly descriptively. When I am unfamiliar with a subject, I sometimes adopt this approach; I produce several paintings of different aspects of the same subject, gradually loosening-up as I begin to feel more confident.

COLOURS
Viridian 4; Blue Green 1, 5 & 8; Hooker's Green 5; Purple Brown 6; Sap Green 1 & 3; Yellow Ochre 4; Vandyke Brown 4; Crimson Lake 0; Cadmium Red 2; Purple 2.

PRELIMINARY SKETCH
My usual practice of making one or two thumbnail sketches helped me to decide upon a composition. I tried to ensure that the lines within the picture led my eye to the main, large water-lily that I positioned on one of the rectangle's focal points.

FIRST STAGE
This time I decided to try a watercolour background for my picture. I roughly moistened a piece of white watercolour paper

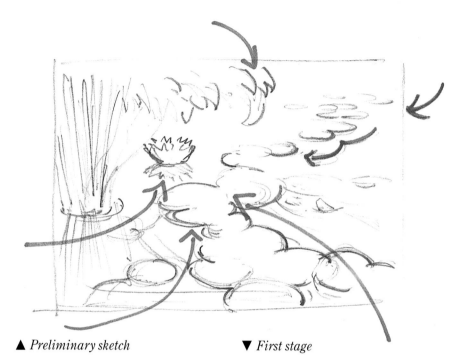

▲ *Preliminary sketch* ▼ *First stage*

with a sponge and then dropped random colours from my watercolour box onto the surface of the paper. The colours ran into each other, creating a softly-diffused, varicoloured surface on which to work. While it was drying, I lightly sketched in the main elements of my composition using a blue pastel pencil.

SECOND STAGE

I worked across the image using side strokes of Blue Green 8, Hookers Green 5 and Purple Brown 6. The dark colours suggested the water's depth and 'revealed' the edges of some of the lily pads. It was important to ensure that the ellipses of the lily pads were correct. Those nearest to me were large and saucer-shaped because I was looking down on them; those farthest away were smaller, shallower and closer together, bunching into a large, simple shape. I checked the proportions by measuring carefully, using the handle of a long brush, the width against the depth of each shape.

THIRD STAGE

The lily pads and border water plants contained a variety of different greens, so I used Sap Green 3, Blue Green 5 and Yellow Ochre 4, stroking the colours on with the sides of the pastels on the lily pads to keep the effect fairly loose. I also defined the shapes of all the plants and leaves by darkening around their edges. I used Vandyke Brown 4 for the small submerged leaf by the reeds, for the bud and some of the submerged lily stalks, breaking the linear strokes here and there to give the impression of water movement above them.

I began to create a sense of the water's surface by stroking on

horizontal marks with my darkest blue and, using the same colour, I painted in the reflection of the lily bud on the right.

▲ *Second stage*

▼ *Third stage*

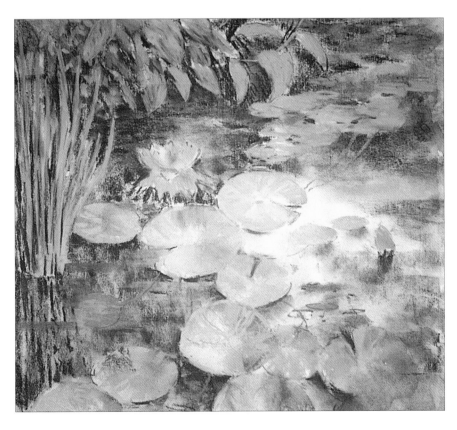

57

FINISHED STAGE

Crimson Lake 0 was used for the lightest petals on the pink lily flower and the distant buds, together with a little Cadmium Red 2 for the small touches of warmer colour on the undersides of some of the petals.

The reflection of the large flower is a simple shape. Purple 2 was stroked over this shape to darken the reflection slightly and the dark blue shadow separated the flower from its reflection.

I worked across the lily pads and plants again with Sap Green 1 using linear marks and short layered side strokes to knit some of the previous colours together.

Finally, I dealt with the water. I used Blue Green 1 for the sky reflections and then, to show how a little water movement on the right broke up the reflections, I used Viridian 4 to hint at large ripples. I used tiny strokes of this colour on some of the lily pads to emphasize their curving cup shapes. Tiny dark blue linear marks suggested the small ripples created where the water bounced gently away from the edges of the lily pads.

▶ *Finished stage*
Water-lilies
35 × 38 cm (14 × 15 in)

▼ *A close-up of the lily pads shows how the pastel has been applied; you can clearly see how curving linear strokes of pastel can help to show how leaves curl up at the edges. Also, you can see how small marks suggest water movement and sky reflections.*

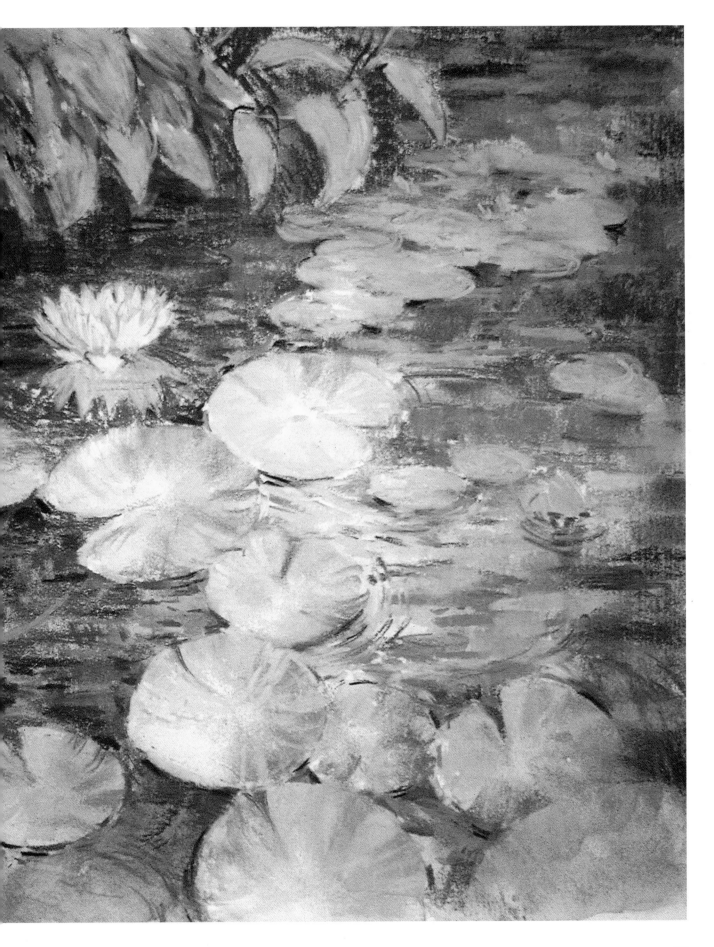

CHANGING SEASONS

Throughout the seasons obvious physical changes occur in a garden because different flowers appear at different times and trees lose or gain their leaves. A heightened sensitivity to seasonal colours can also be helpful when you want to emphasize a particular season in your paintings, since your choice of colours can strongly influence mood and atmosphere.

Springtime colours tend to be vivid and fresh, with clean sharp greens and yellows, and the cool blue sky is often tinged with grey. Crocuses and daffodils herald the spring, magically brightening the scene with purple and yellow – perfect complementary colours. Trees burst into soft, pale blossom. Have you ever stood under a blossom-laden tree and looked up into its pink depths? Do try it – the colour seems to wash over you.

The richer and warmer colours of summer soon follow, and as summer draws to a close, autumn leaves turn to copper and bronze, jewel-coloured fruits and berries appear, and the garden is bathed with honey-coloured light. Often, spires of blue-grey smoke can be seen as bonfires glow red and orange.

Then comes winter, a time of dramatic tonal contrasts: the crisp, pale colours of frost and snow; the deep green leaves of the evergreens; and purple-black branches and tree trunks. A light dusting of frost will bring magic;

the garden becomes a fairytale scene of iridescent soft greys, dusty fawns and gentle purples, hazily illuminated by the pale light of a weak winter sun.

Winter is not the perfect time for outdoor painting but the subtle colours of a winter garden can sometimes prove irresistible.

Cold weather may prevent a prolonged outdoor painting session, however, you may be able to paint comfortably from a window. Alternatively, do dress warmly and venture out with a sketchbook occasionally – winter photographs seldom capture the subtleties of colour seen by the

▲ *A springtime palette of cool lemon-yellows and pinks, acid yellow-greens and sharp blue-greens. The overall feeling is cool, bright and fresh, reflecting spring's new growth.*

▲ *Autumn's colours are warmer still – the mellow oranges and golds glow in all weather conditions, contrasting beautifully with cool purples, blues and khaki greens.*

▲ *Here are some of summer's cool and warm greens, warmer yellows and reds, and dynamic blues and purples. The palette is subtly warmer now as the garden matures.*

▲ *A winter palette provides strong contrasts of light and dark, together with the subtle blue-, green- and purple-greys of frost and snow, and touches of brighter colour.*

◄ Rain threatened, so I rushed into the garden to collect some berry-laden branches and autumn leaves; I placed them flat on a piece of white paper and treated them as a rather 'free' still life. I covered my piece of white watercolour paper with floaty watercolour washes in autumn colours of red, orange and gold. When this was dry, I worked over it with pastel pencils.

eye and quick sketches, perhaps done with pastel pencils, or with written colour notes, will reinforce your memory of the scene and will back up any photos you may take.

You could also collect material for use in a still life painting – gnarled pieces of wood; bunches of shiny berries, fir cones, seed heads, tiny winter blossoms and variegated greenery.

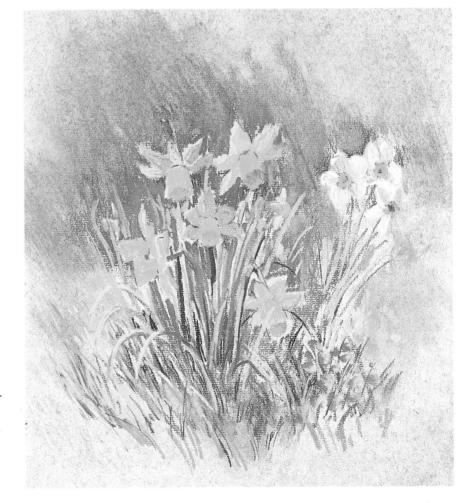

► Springtime's show of daffodils is always a joy to behold; their brilliant yellow blooms and sharp green foliage light up even the dullest of days. When you paint them, make sure you have a variety of yellows to choose from – their petals are often lighter than their trumpets and petals in shadow, like the central flower here, are often quite dark and greeny-bronze. Don't the little pale narcissi look lovely beside their stronger-coloured neighbours?

WINTER GARDEN
DEMONSTRATION

Snow rounded the forms of the evergreen shrubs and iced the tree branches. Sunlight, surprisingly golden, streamed across the garden from the right, casting blue and purple shadows. I donned thick-soled boots, and while the sun took the chill off the air, I did a simple colour study on a pastel pad. I later used this as the basis for a bigger picture, completed in the warmth of my studio the following day. Although the snow had practically disappeared overnight, my memory of the scene was still strong as I had taken the time and trouble to sketch on the spot.

COLOURS
Purple Grey 4; Olive Green 2 & 8; Green Grey 6; Prussian Blue 6; Cobalt Blue 2; Purple 2; Yellow Ochre 0 & 4; Vandyke Brown 4; Burnt Sienna 6.

PRELIMINARY SKETCH
My little thumbnail sketch helped me to realize that I could use two compositional devices to direct attention to the little seat beyond the arch; the lines within the picture and the element of 'counterchange' – a light bench against dark trees, and the dark shadow beneath the bench against the white snow on the ground.

FIRST STAGE
I sketched the main elements of the composition onto a piece of warm brown pastel board. The velvety surface is made of

powdered wood that grips the pastel firmly. I began with a stick of white conté crayon and then added rough side strokes of Purple Grey 4 to define the main light and dark areas in the

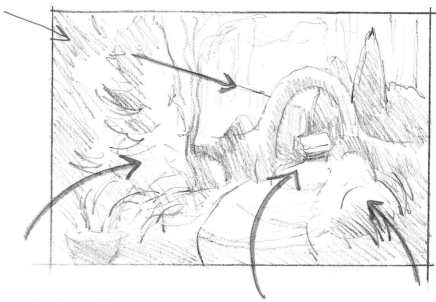

▲ *Preliminary sketch*

▼ *First stage*

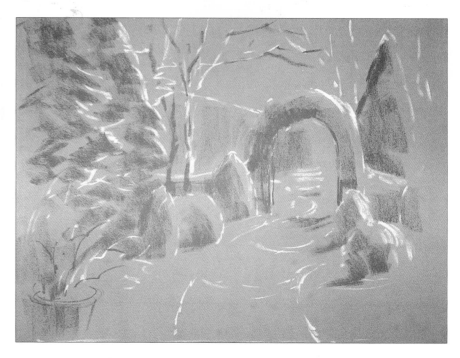

composition. I wanted to lead the eye through the archway into the garden beyond – to the sunlit snow and garden bench in the background.

SECOND STAGE

Winter gardens offer lots of rich, damp darks, and when you look closely you can find a surprising variety of colours. I decided to build up the areas of foliage first, using my darkest pastels – Olive Green 8, Green Grey 6, Prussian Blue 6 and Purple Grey 4.

Then I started to indicate the shadowy areas of snow, using Cobalt Blue 2 and Purple 2. Side strokes of pastel on pastel board have a certain softness. If you keep your tones fairly close, you can build up a network of colours which blend visually without the need to blend with your fingers. Broken colour used in this way is very effective for shadowy areas, since the colours will vibrate and look far more interesting that if you used one colour.

THIRD STAGE

While I had been sketching in the garden, I noticed that the sky's creamy-yellow glow, much to my surprise, was slightly darker than the lightest, sunlit areas of snow. I used Yellow Ochre 4 to begin with, blocking it in with side strokes, allowing the colour to drift over the tree branches. I modified this rather strong colour by scumbling Cobalt Blue 2 lightly over the top in places, blending with my fingertips for a softly diffused effect.

Then I used linear strokes of Olive Green 2 and Vandyke Brown 4 to re-establish the branches of the trees in the background. I used a warmer colour, Burnt Sienna 6, for the lovely tangly foreground shrubs.

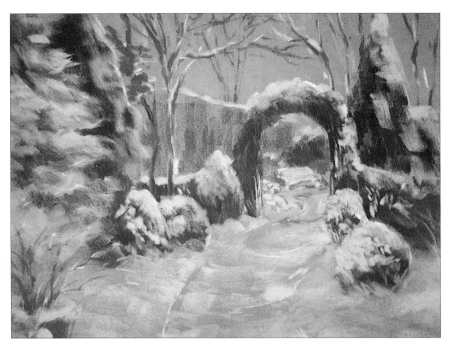

▲ *Second stage* ▼ *Third stage*

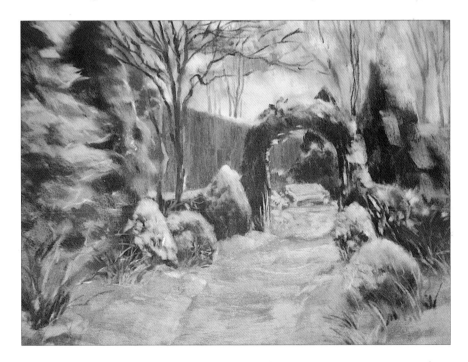

FINISHED STAGE

Finally, I allowed myself the luxury of painting the sunlit snow, using firm strokes of Yellow Ochre 0. The foreground strokes were larger than those beyond the arch to help emphasize recession; the broken nature of the strokes meant that the colours underneath showed through in places, adding interest and variety. I painted small, shadowy pits and hollows in the snow with the blues and purples.

Then I worked across the whole image, completing it by gradually refining details and adding tiny touches of warm and cool colours. You will often find rich, warm brown leaves and tiny copper-coloured branches enlivening a snow scene; they make the cold, blue areas seem even colder by contrast.

After a long, critical look at the image, I decided that the fence did not look right – it was not sunlit enough – so gentle side strokes of Yellow Ochre 4 drawn over the existing colours brightened and warmed the wood. At last I was satisfied – a snowy garden scene – and not once did I use a white pastel!

▼ *Finished stage*
Winter Garden
35 × 46 cm (14 × 18 in)

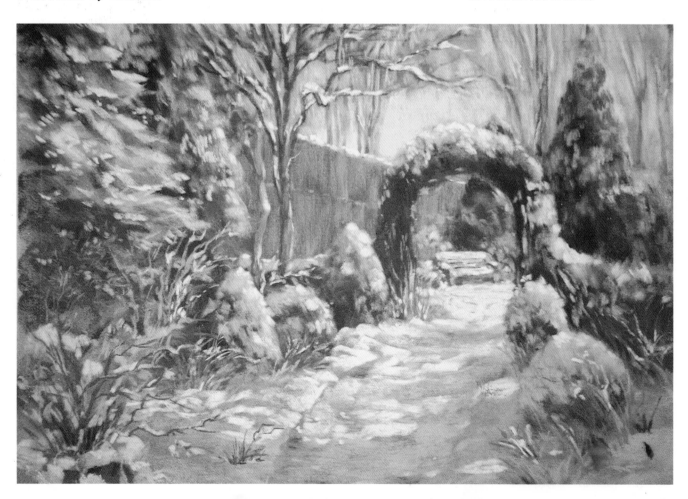